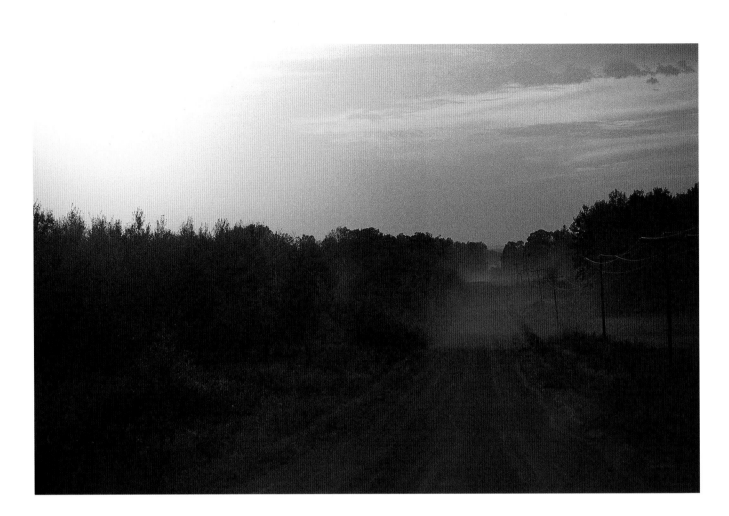

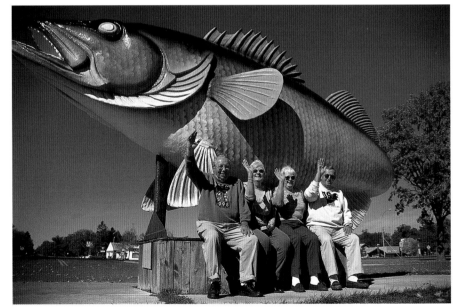

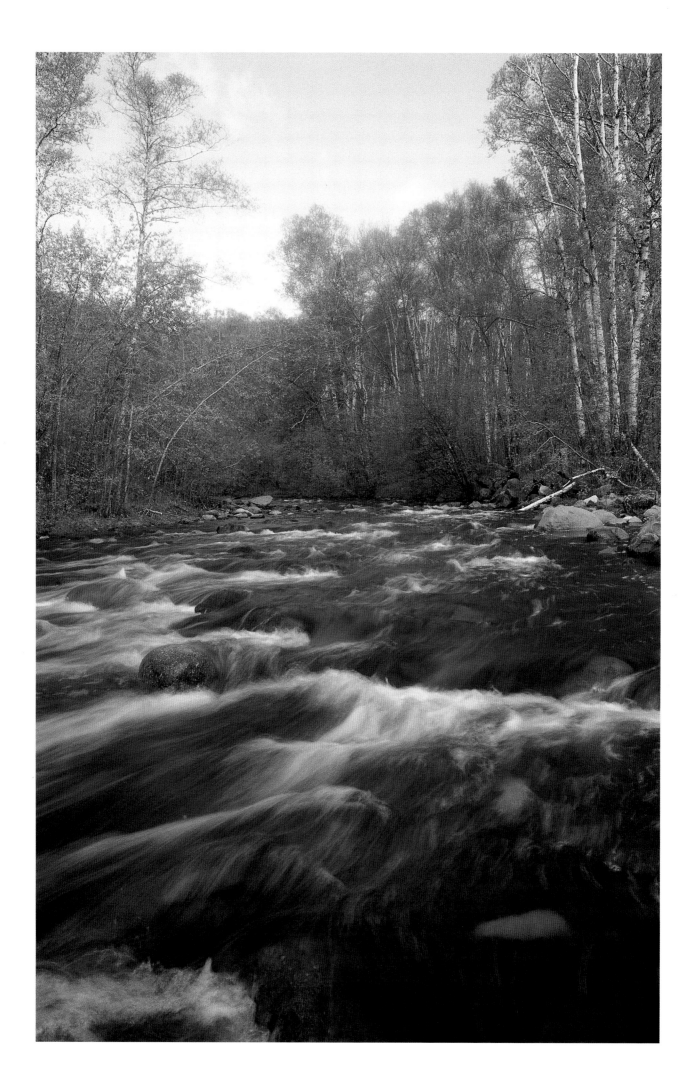

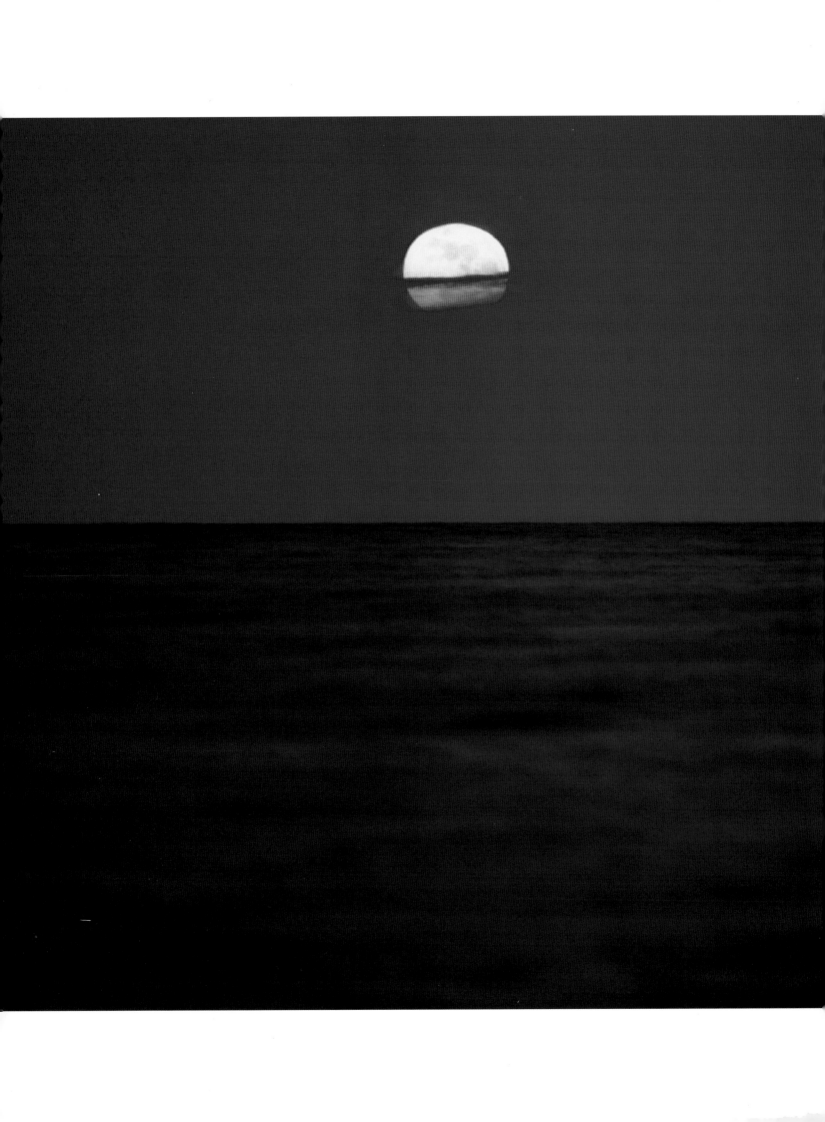

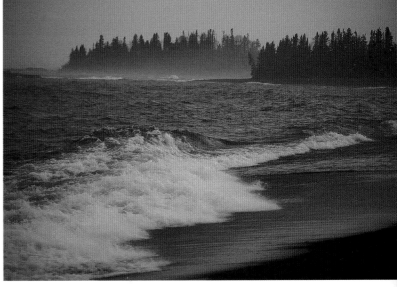

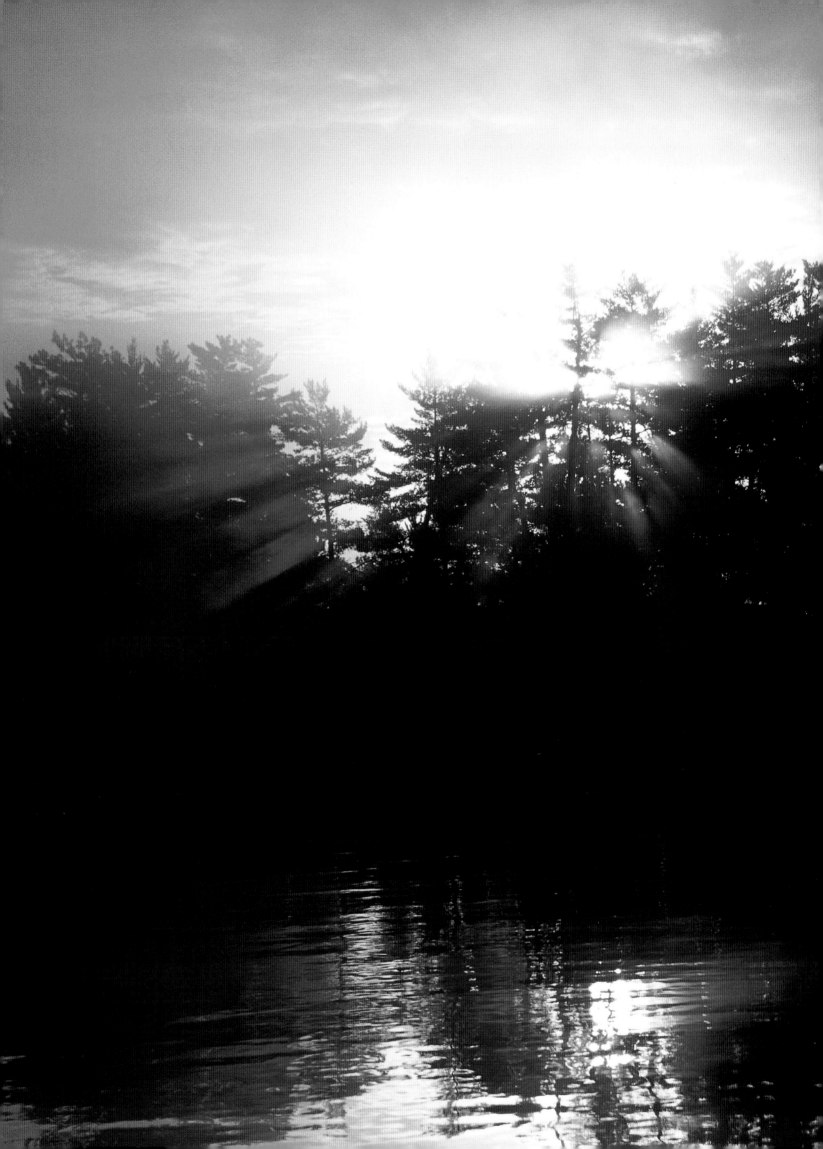

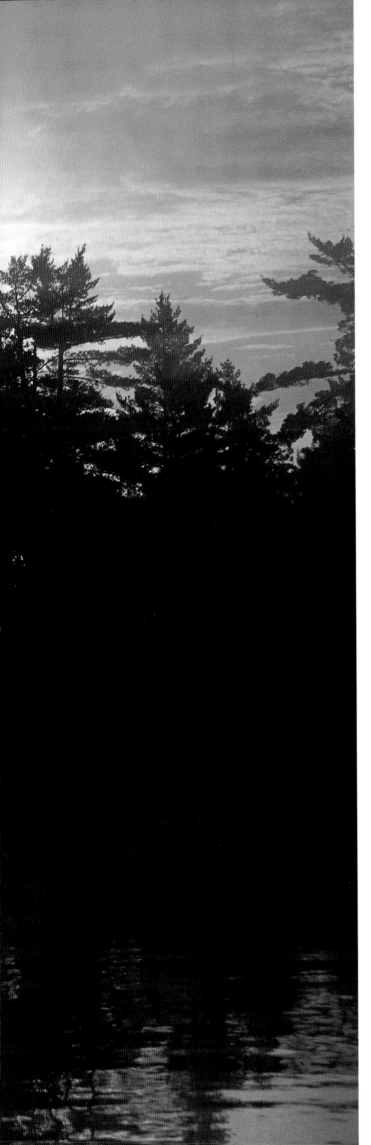

Only in Minnesota

Photography by Roxanne Kjarum
Text by Berit Thorkelson

Voyageur Press

Dedications

To Mom and Dad—*Tusen Takk*! —RK

For Eric —BT

Photography © 2003 by Roxanne Kjarum
Text © 2003 by Berit Thorkelson

Edited by Michael Dregni and Amy Rost-Holtz
Designed by JoDee Mittlestadt
Printed in Hong Kong

03 04 05 06 07 5 4 3 2 1

Library of Congress Cataloging-in-Publication Data

Kjarum, Roxanne, 1953–
 Only in Minnesota / photography by Roxanne Kjarum ; text by Berit
Thorkelson.
 p. cm.
 ISBN 0-89658-534-4 (hardcover)
 1. Minnesota—Pictorial works. 2. Minnesota—Description and travel.
3. Minnesota—Social life and customs. I. Thorkelson, Berit, 1971–
II. Title.
 F607 .K58 2003
 977.6—dc21

 2002153572

Distributed in Canada by Raincoast Books, 9050 Shaughnessy Street, Vancouver, B.C. V6P 6E5

Published by Voyageur Press, Inc.
123 North Second Street, P.O. Box 338, Stillwater, MN 55082 U.S.A.
651-430-2210, fax 651-430-2211
books@voyageurpress.com
www.voyageurpress.com

Educators, fundraisers, premium and gift buyers, publicists, and marketing managers: Looking for creative products and new sales ideas? Voyageur Press books are available at special discounts when purchased in quantities, and special editions can be created to your specifications. For details contact the marketing department at 800-888-9653.

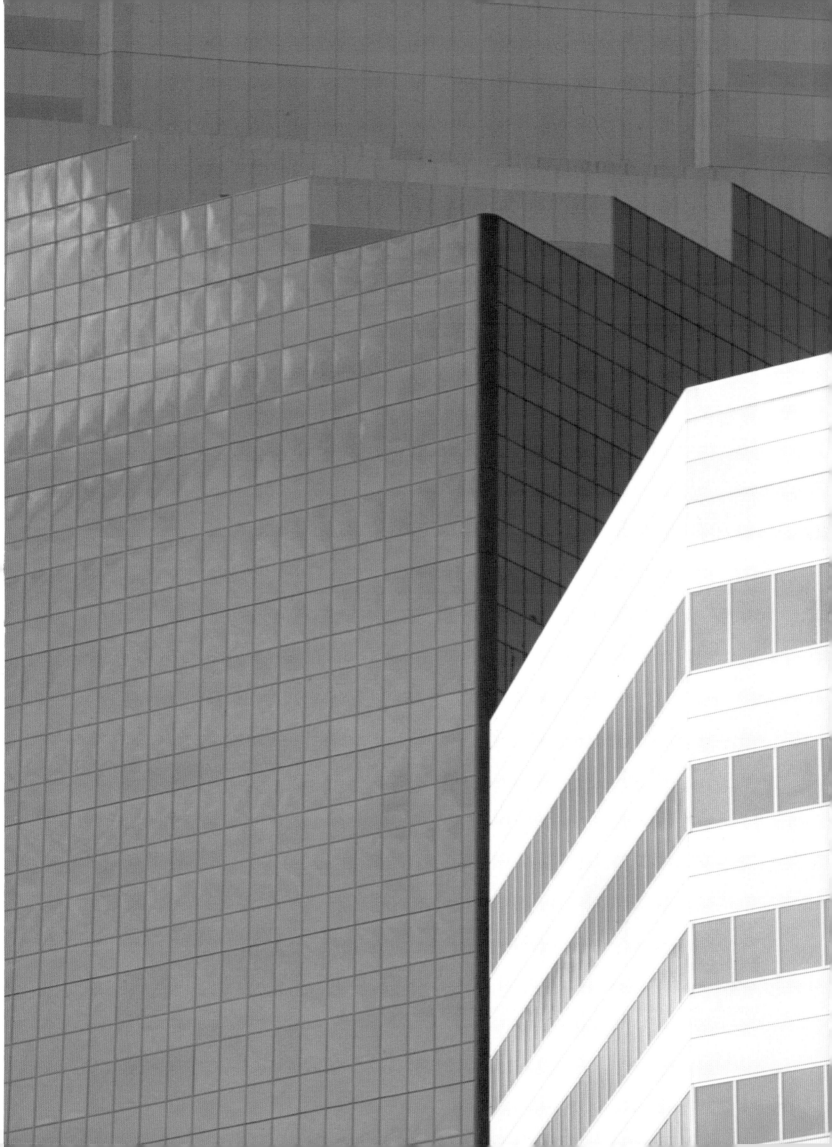

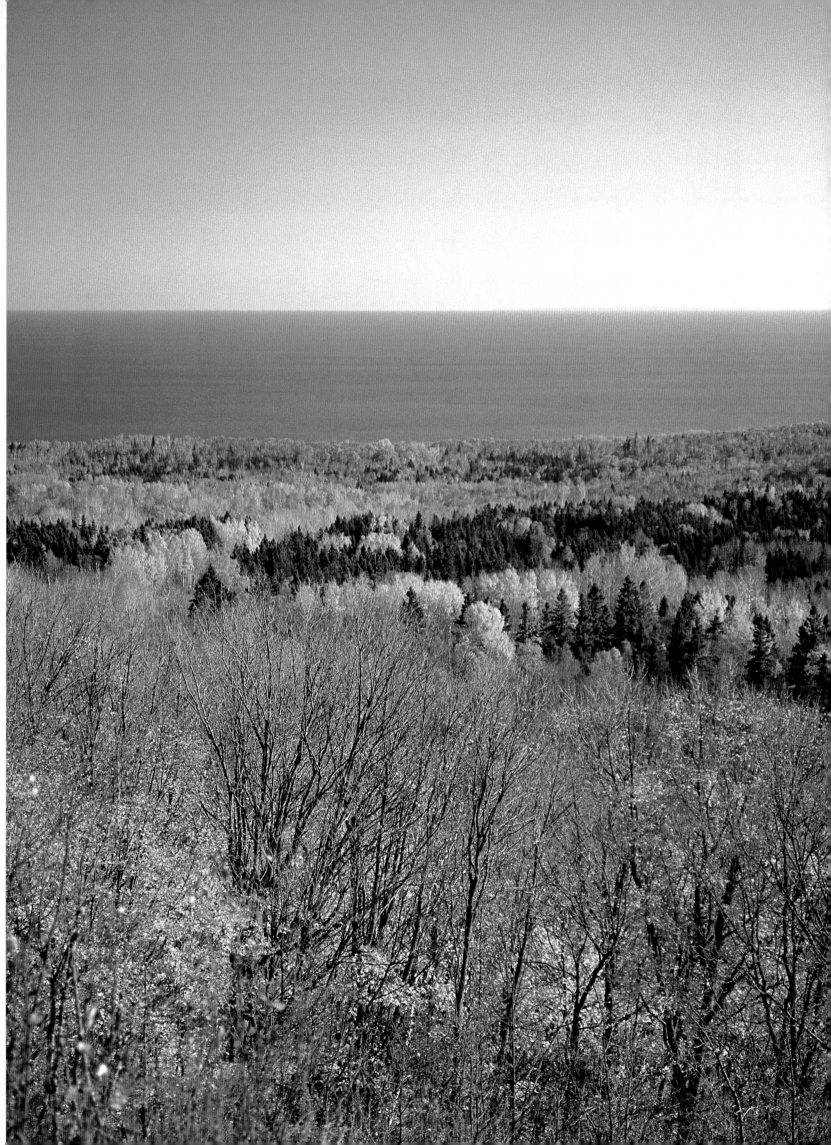

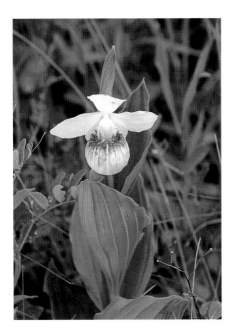

Introduction

*M*innesota is officially the most livable state in America. Morgan Quitno Press, a private research and publishing company in Kansas, developed its Most Livable State Award in 1991, and for the first six years, Minnesota floated around spots two, three, and four. Six years ago it reached number one, and it hasn't moved since.

What makes a state livable? According to Morgan Quitno, forty-three factors, all of which are assigned a numeric score. They include pupil-teacher ratios in public elementary and secondary schools, percentage of the population with health insurance, books in libraries per capita, highway fatality rates, teen birth rates, job growth, and voter turnout. Minnesota consistently ranks extremely well in every category except for one: average daily mean temperature.

The award comes as no surprise to Roxanne or me. Both of us have experienced much of Minnesota in much the same way. We grew up in separate small towns in southern Minnesota, and each of us now lives in one of the Twin Cities. Roxanne has a cabin "Up North," and she devotes much of her free time to exploring and photographing back roads across the state. I have spent most of my adult life writing travel articles, a good portion of them about Minnesota.

Roxanne has traveled extensively throughout the United States and Mexico. I've lived in other states and countries and done my fair share of traveling worldwide. But for both of us, our home state always holds a special place. We love to explore Minnesota for work and for pleasure.

Facing page: *This view from Britton Peak is an example of one of the stunning sights afforded along the Lake Superior Hiking Trail. The trail's two-hundred-plus miles draw day as well as overnight hikers.*

Above: *Minnesota's state flower, the pink-and-white lady slipper, is actually quite rare. If you want to catch the blooms, you'll find them in late June or early July, in eastern and northern Minnesota's swamps, bogs, damp woods, and roadsides.*

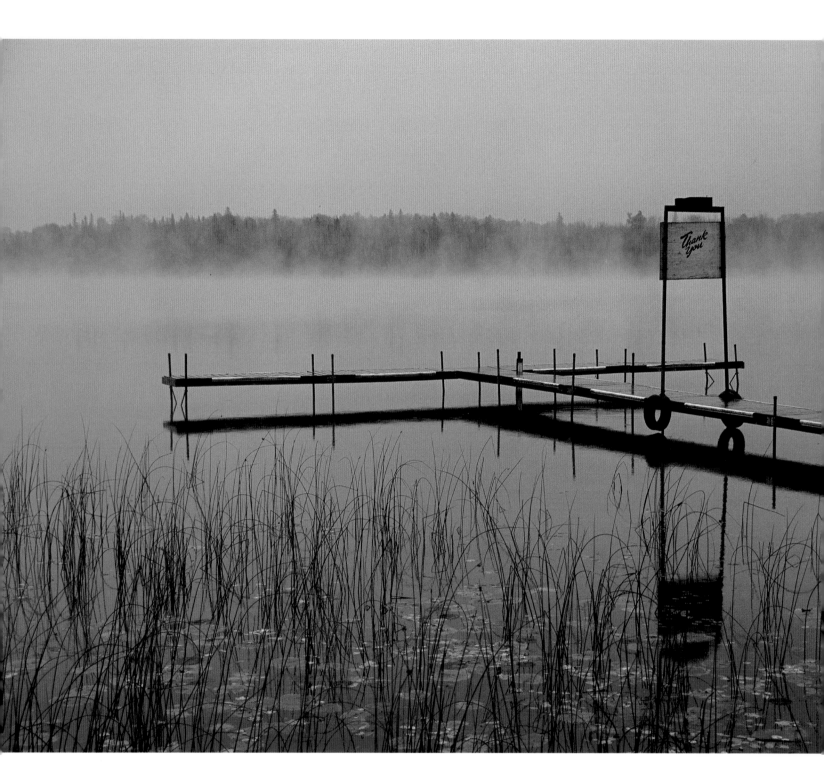

A mystical fog hangs over the surface of this placid lake in Grand Rapids resort country.

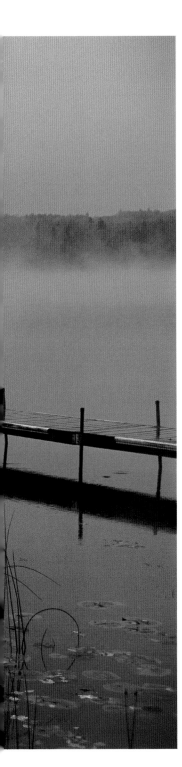

Compiling this book combined the two. We covered a lot of territory in the name of research. We attended festivals throughout the state, each one more fun than the next. The beauty of our state never ceased to surprise even these lifelong Minnesotans. Neither of us had been to the Northwest Angle, for example, and we were both amazed by the story of its existence as well as the incredible experience of being there. Roxanne even traveled to the actual four corners of Minnesota, where our state (or country for that matter) ends and another begins. The diversity of those four spots is absolutely striking—the vast possibility of a southwestern gravel road, the gentle geography of a southeast landscape fading into winter, the plummeting waters of the High Falls along the northeast's ragged cliffs, and the alternating seas of green and deep brown that is the Red River Valley of the northwest.

No matter where we traveled we got a welcome earful. Minnesota residents were more than willing to tell us what makes their corner of the state special. One time we left a note on an unoccupied senior center in Lake George soliciting information about what goes on inside. Martha Johannsen sent back a wonderful ten-page handwritten letter extolling the many virtues of the tiny town, from the history of its volunteer fire department and its annual Baked Bean Day to the kindness of the people who live there. If Minnesotans are anything, they're proud—as they should be. Receiving an award like Most Livable State only reinforces that pride.

Not to be ungrateful, but about that weather ranking—we respectfully suggest that the award's standards might be skewed. Our winters are not a bad thing. They are part of what makes Minnesota what it is and Minnesotans who they are. But that's splitting hairs. We do appreciate the award. It validates something Roxanne and I have always known but was made even more clear during the compilation of this book: In Minnesota, even in—and sometimes especially during—winter, we have it good.

Destination Minnesota

More than ten thousand years ago, ice packed a mile thick covered what is now Minnesota. As the glaciers patiently retreated, they left behind eroded holes filled with melted ice. Today these holes have names such as Winnibigoshish and Vermilion, Leech and Mud, and they are by far Minnesota's most attractive natural resources. It's these lakes, along with myriad streams and rivers, that give Minnesota more shoreline than California, Florida, and Hawaii combined.

"Up North" is short for "a campsite, cabin, or lodge near a lake somewhere in northern Minnesota." Each season arrives with its own set of lake activities, from fishing and canoeing to waterskiing and swimming. At the very least, you can't help but enjoy the view.

Of course, other exceptional vacation sites exist on the land between the many lakes. Some of the state's best historic small towns, beautiful bluffs or woodlands, and picturesque hiking or paved bike trails are miles from any large body of water. But considering since there are just two counties in the entire state without a natural lake, recreational water, if desired, is never far away.

It was the name of a river, not a lake, that appropriately summed up the feel of the entire state. American Indians called the river *minisota,* meaning "sky-tinted waters." European settlers Anglicized the word to *Minnesota*, a name the state and the river now share. It's an appropriate title for a place whose glacially carved, glistening blue beauty has never been lost on anyone.

Weather

In the summer of 1936, a heat wave swept through Minnesota. People crowded around lakeshores and lingered indoors near one-hundred-pound chunks of ice. It's been said that half of Minneapolis slept outside because nighttime temps were so unbearable. When the heat reached its height in July, the mercury inched over 114 degrees in Moorhead—that's hotter than the hottest day ever recorded in Hawaii or Florida.

Heat is not what most people expect of Minnesota, a state widely known for its winters. Though we can't deny our frosty reputation is well earned, it's worth pointing out that we have more than one season—four of them, to be exact. And each is more beautiful than the next.

During spring, rains and street sweepers banish the dingy remnants of winter, and people find every excuse to be outdoors. Buds on trees turn into full-fledged leaves overnight, and the scent of lilac drifts through window screens. Soon enough, summer arrives, full of backyard barbecues and trips to the nearest lake. When summer fades into fall, green leaves turn fiery colors all across the state, before, all too quickly, they disappear.

Then, again, it's winter. People who live here like to say with pride that if it weren't for winter, our population would skyrocket. Not everyone has what it takes to be a Minnesotan. Minnesotans are tough. We

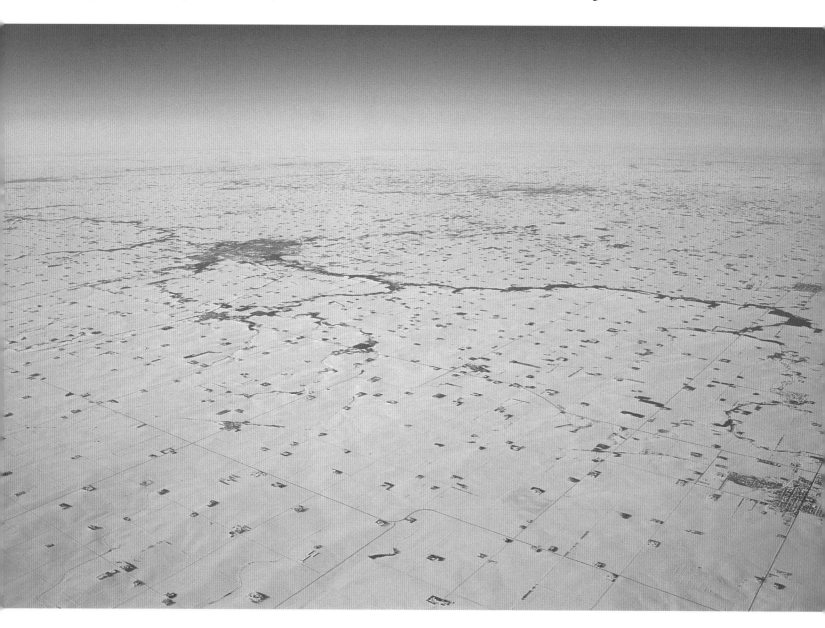

Facing page: *An aerial view of south-central Minnesota in January, typically the state's coldest month, reveals a sea of white.*

Above: *International Falls lives up to its reputation as "the Icebox of the Nation." Temperatures generally hit their lowest point in January.*

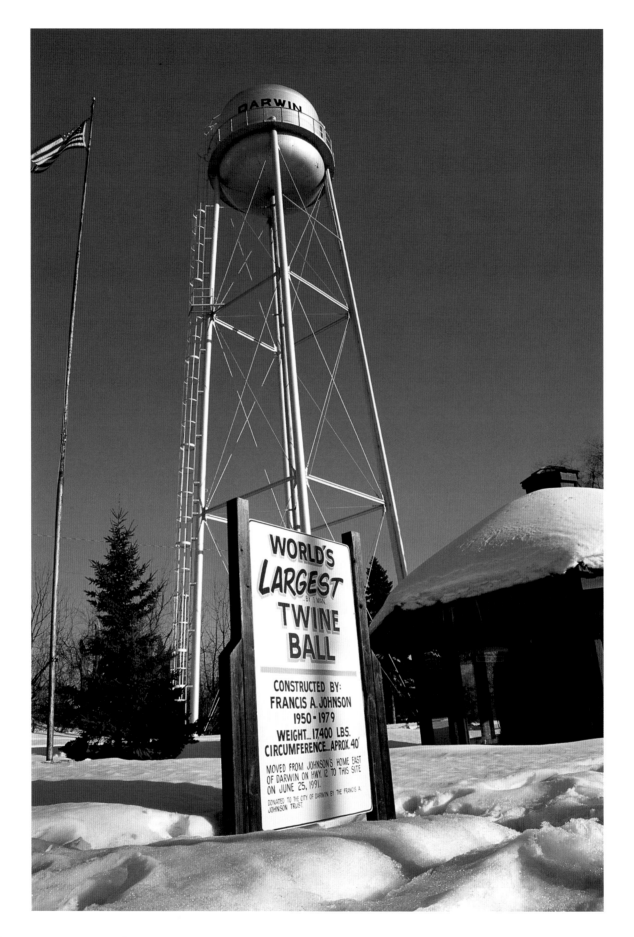

After twenty-nine years of winding twine, Francis Johnson of Darwin ended up with a ropey mass over eleven feet tall. Upon Johnson's death in 1989, the Darwin Community Club hauled the World's Largest Ball of Twine by One Man from Johnson's farm into town. The club eventually built a gazebo around the ball to protect it from the elements and tourists looking for souvenir clippings.

here are a few generalized phrases to describe modern-day Minnesotans: civic minded, seasonally adaptive, outdoorsy, helpful.

These traits combine to form the fundamental group psyche of the over four million people who live in the eighty-four-thousand-square-mile landmass bordered by Wisconsin, Iowa, the Dakotas, and Canada. True, they might not always tell you to have a nice day. But chances are that when they do, they mean it.

The Interesting and the Obscure

Francis Johnson liked to collect things just because he could. Nail aprons, pencils, farm implements—anything he could get more than two of was fair game. One day in 1950, Johnson wrapped some baler twine around two fingers, and his most famous collection was born. For the next twenty-nine years, he added to that ball of twine, until it became the largest of its kind in the world.

Upon Johnson's death in 1989, the Darwin Community Club became keepers of the twine ball. Once, representatives from Ripley's Believe It Or Not! came to Darwin hoping to buy the town treasure. "Who's going to see it in Darwin?" they asked. Unfazed, the Community Club declined the offer, and the twine ball still stands in downtown Darwin. It's an example of an "If you build it, they will come" attraction—one of many scattered throughout the state.

Manmade curiosities like the twine ball and natural wonders like the Little Cedar Spirit tree are just two of the wide variety of interesting and obscure offerings that exist solely in Minnesota. Some you can't miss, like the giant statues of Paul Bunyan and assorted fish. Others require an inquisitive mind, one that would ask questions like "Why is there a hump on the otherwise straight Canadian border?" or "What on God's green earth are those giant white windmills?"

Once you start asking questions, you get answers that, oftentimes, just beg for more questions—like the twine ball. There it sits, over 8.5 tons of twine, all wound by one man. Dig deeper if you like—there's an interesting story guaranteed. Or go ahead and take it at face value. Either way, the conclusion is the same: Only in Minnesota.

Festivals and Celebrations

In Braham it's pie. Since the 1930s, the town's local café has held a reputation for out-of-this-world pastries. In a way, every day is pie day in Braham since the café is open seven days a week. But Braham citizens know their pie deserves more. Each August, the café pumps out 750 of them and officially declares one day as Pie Day.

In Walker, they celebrate a blotchy bearded fish. When February arrives and cabin fever is at its strongest, citizens head for the ice during the International Eelpout Festival. Yes, they know it's strange. It's supposed to be.

Zumbrota honors its covered bridges. Minneota lauds the boxelder bug. Montgomery commemorates its Czechoslovakian heritage. And Ramsey, well, it throws an enthusiastic, daylong nod toward happiness.

Each year, town residents and otherwise affiliated groups in every Minnesota nook and cranny find reasons to have a party. A natural resource, a local landmark, a political cause, a thwarted bank robbery—any imaginable catalyst will do. Some festivals are bona fide traditions with histories older than the state itself. Others seem just thinly veiled, but justifiable, excuses to get out among friends and neighbors and have a good time.

Whether it's a few hundred people in the town park eating sloppy joes while the kids play tag or a quarter of a million people listening to national bands play on closed-off city streets, all Minnesota gatherings have at least one thing in common: They really do offer good reasons to celebrate.

Wild Minnesota

For years, Minnesota's first state park existed only on paper. In 1889, surveyor and explorer Jacob Brower confirmed Lake Itasca as the source of the Mississippi. Four years later, he convinced the state government to declare the lake and surrounding pines a state park. As the park's first commissioner, Brower used personal money to acquire state parklands from the homesteaders and railroad and timber companies.

Even during the sometimes heated struggle for land and even though it was much less developed than it is today, vacationers came to Itasca. Today, extensive hiking, biking, and cross-country skiing trails winding through virgin pine forests; historic log cabin accommodations; and a paved, self-guided interpretive walk to the Mississippi headwaters make Itasca one of Minnesota's three most visited state parks.

Department of Natural Resources (DNR) statistics show that there is a state park within fifty miles of every Minnesotan. When you add Voyageurs National Park, the Boundary Waters Canoe Area Wilderness, and the many trails, recreation areas, scientific and natural areas, wayside rests, and state and national forests, Minnesota has a mind-numbing amount of opportunities for experience the outdoors.

At Forestville/Mystery Cave State Park, check out stalagmites, stalactites, and underground pools in a cave where it's always a temperate forty-eight degrees. At Lake Bemidji State Park, follow the boardwalk into the bog, where orchids, showy lady slippers, and insect-eating sundew bloom. From candlelight skiing at Lake Bronson State Park to an interpretive antique train ride through the St. Croix River Valley from William O'Brien State Park—there is more to Minnesota natural areas than just hiking trails, swimming beaches, and fishing piers.

The state's abundance of natural, scenic, and cultural resources make it easy to get outdoors and have some fun—no matter what fun means to you.

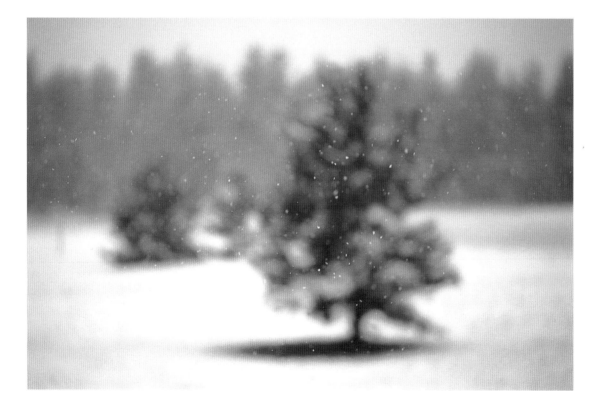

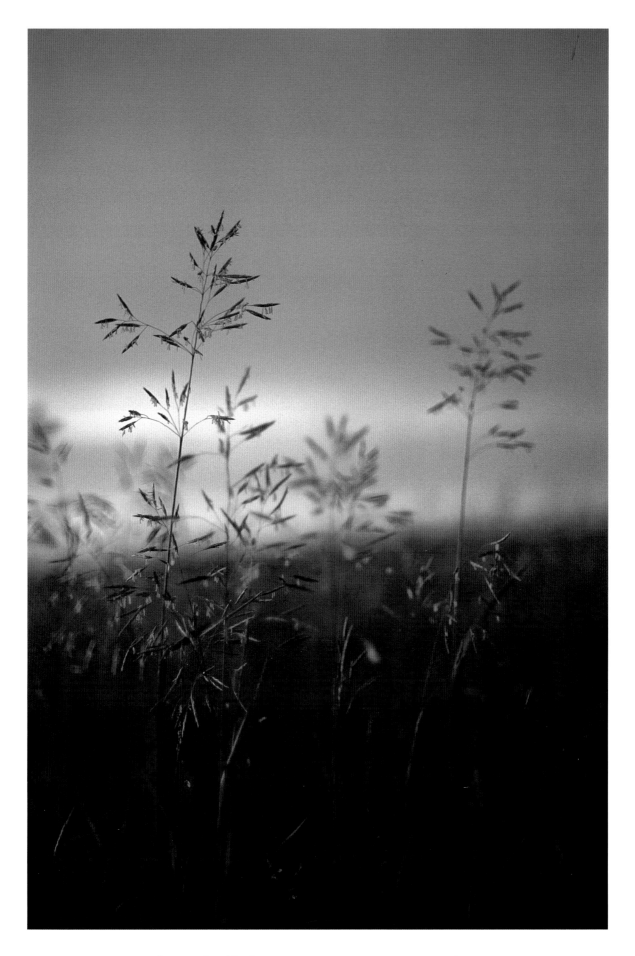

Facing page: *Snow caught in midair blankets a young pine.*

Above: *Roadside grasses in southern Minnesota are delicately illuminated at sunset.*

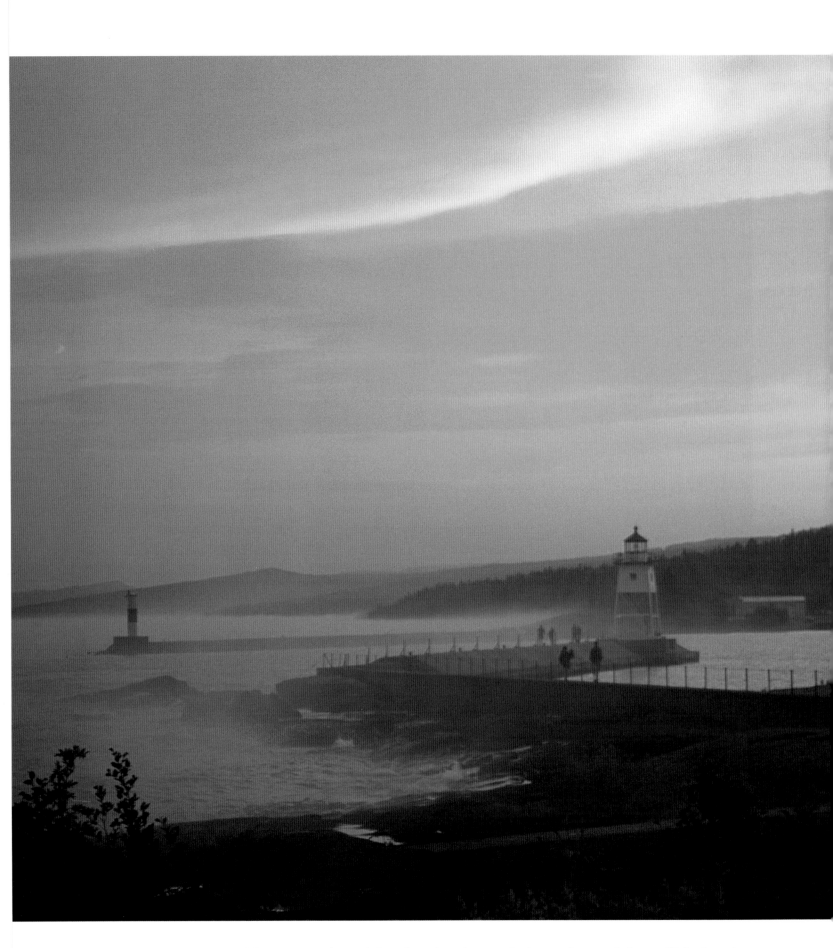

At the northeasternmost tip of the state, Grand Marais hosts lots of tourists vacationing on the rugged shores of Lake Superior. The lighthouse, pictured here at sunset, is a popular historical attraction.

Above, both photos: *Lake Superior's North Shore draws over three million tourists annually. Most people's activities relate to the lake somehow, whether they are scuba diving, boating, fishing, or just appreciating incredible views.*

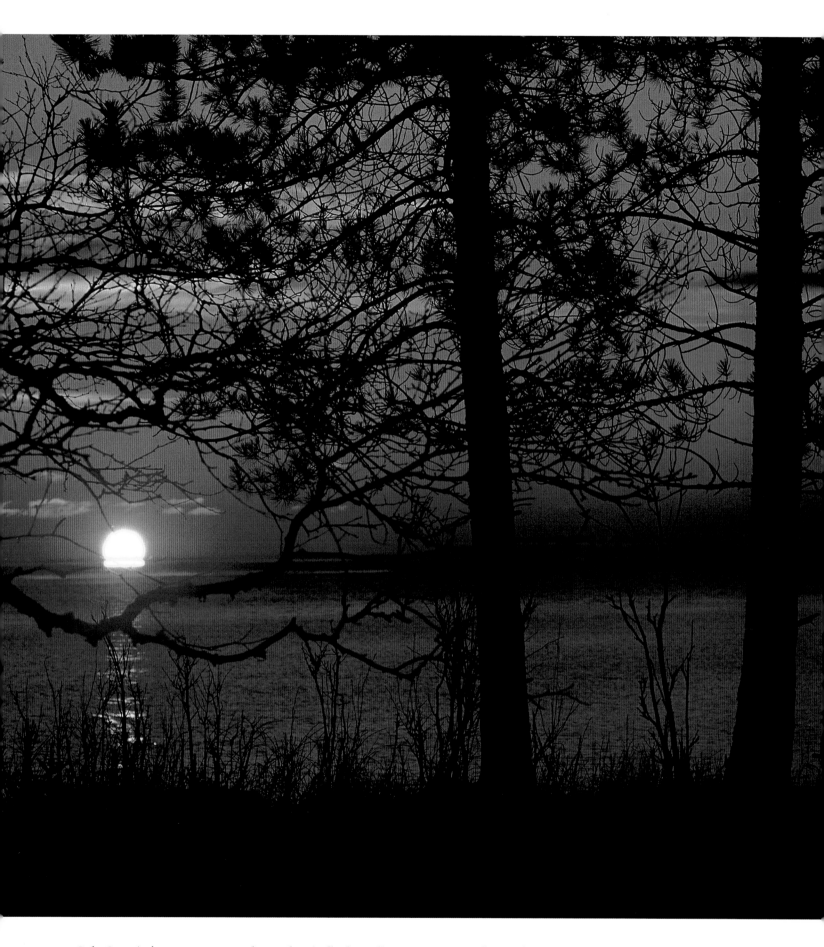

Lake Superior's appearance can change drastically depending on season, weather, and vantage point.

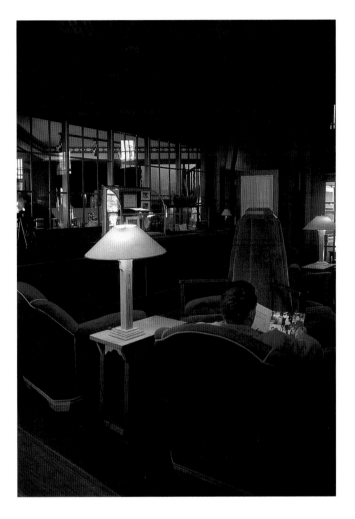

Naniboujou Lodge, located northeast of Grand Marais, was named for the Cree Indian spirit of the outdoors. The lodge is known in part for its unique Cree-inspired paint job, shown here in the lobby.

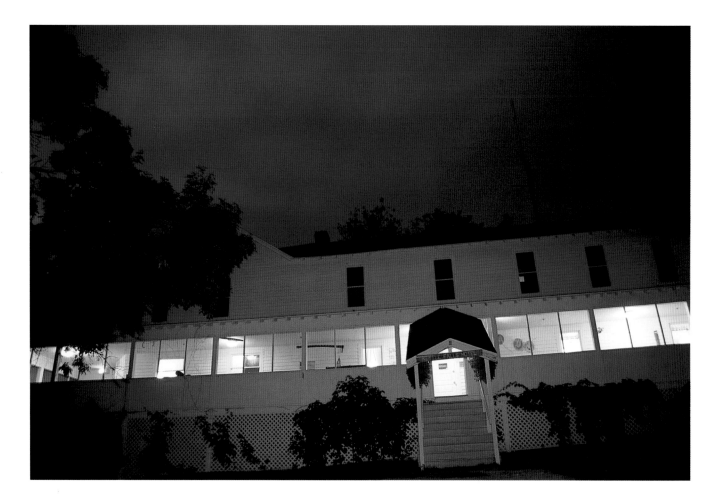

Both photos: *Only a boat or a floatplane will get you to the Kettle Falls Hotel, Voyageurs National Park's only indoor accommodations, located twenty-five miles from the nearest road. Built in 1910, loggers, commercial fishermen, and fur traders stopped in for entertainment, relaxation, and a place to spend the night. Today's visitor seeks (and finds) the same amid the hotel's characteristic slanting floors.*

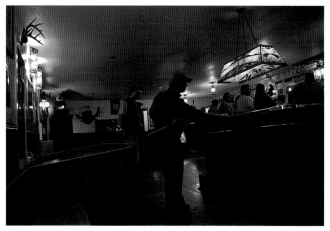

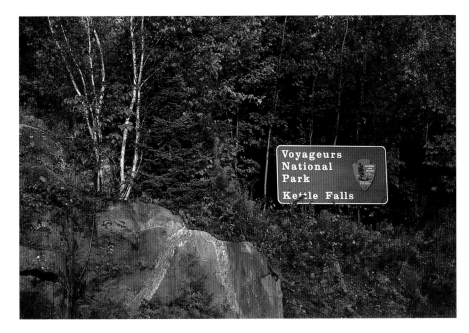

Left: *Voyageurs National Park, Minnesota's only national park, is relatively undiscovered. It's easy for visitors to hole up, alone, in a quiet bay and feel as though the rest of the world has disappeared.*

Below: *Whether visitors enter Voyageurs National Park from Canada or stateside, the vast majority come via watercraft. The park is over one-third water, and lakes fence in most of its 134,000 land acres.*

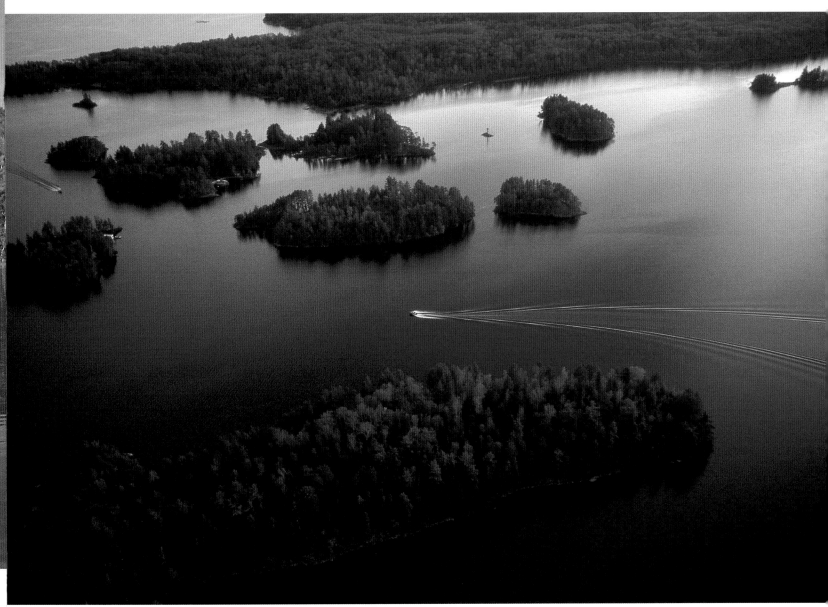

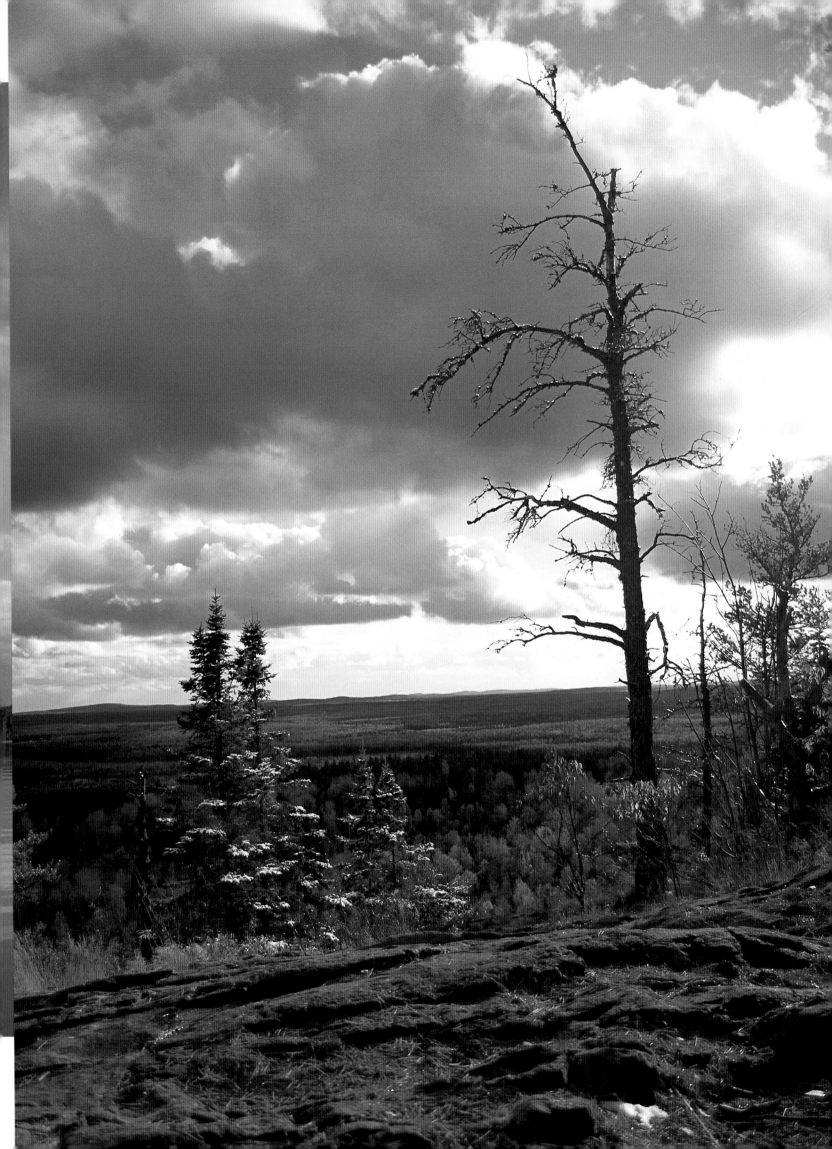

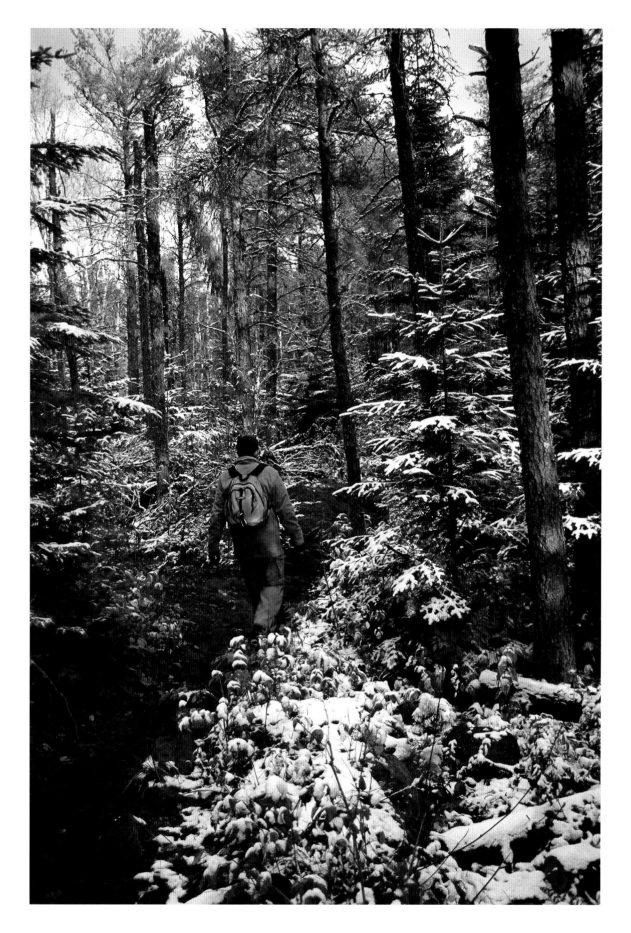

Both photos: *At 2,301 feet above sea level, Eagle Mountain in the Superior National Forest is easily the highest point in the state. This sometimes surprises hikers used to Minnesota's relatively level terrain. One view from the top of Eagle Mountain includes Lake Superior, the state's lowest point at 602 feet. Other oft-seen sights include wolves, waterfalls, and, at the beginning and end of each year, snow-covered pines.*

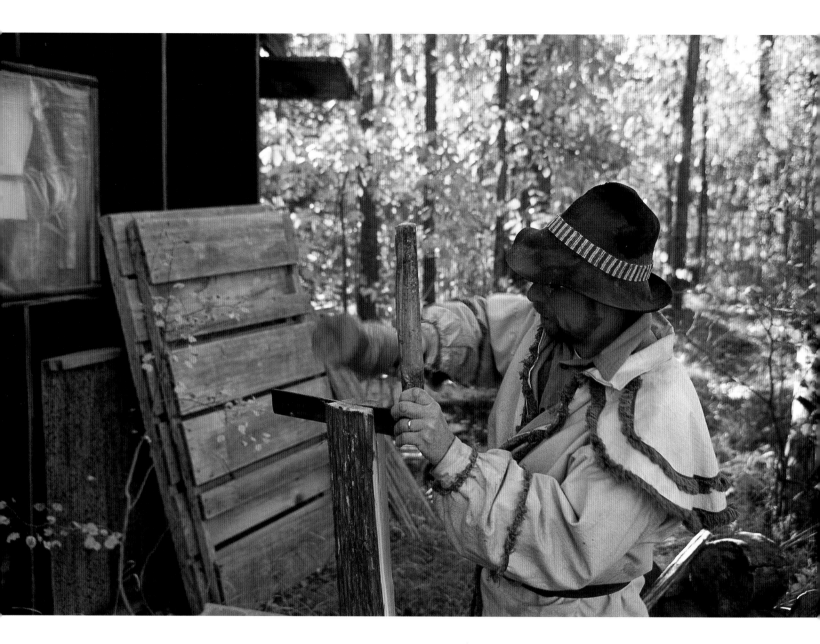

Both photos: *Like the Native Americans and later French voyageurs, Ray Boessel gathers birchbark, splits cedar, and pulls black spruce roots to construct canoes from the ground up. He's one of few professional birchbark canoe makers in the country, constructing and selling about a dozen canoes annually.*

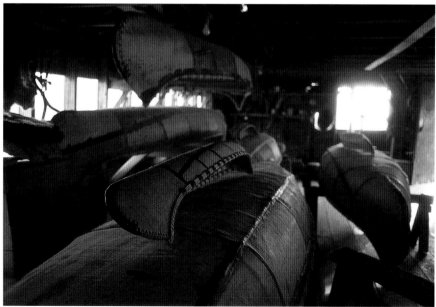

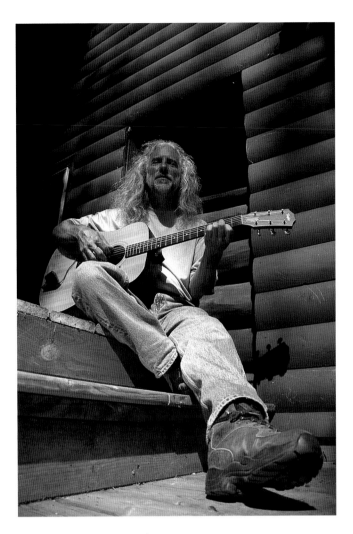

Left: *Michael Monroe sings of respecting the environment and following your own path. He most definitely practices what he preaches. Pictured here in front of his solar-powered North Shore log cabin sound studio, Monroe mixes guitar, vocals, and bamboo flute to create original music.*

Below: *Every June, about nine thousand runners from around the globe tackle the rolling, winding 26.2-mile route that starts in Two Harbors and follows the Lake Superior shoreline to Duluth. Grandma's Marathon ends downtown at Canal Park, home of the race's namesake and original sponsor, Grandma's Restaurant.*

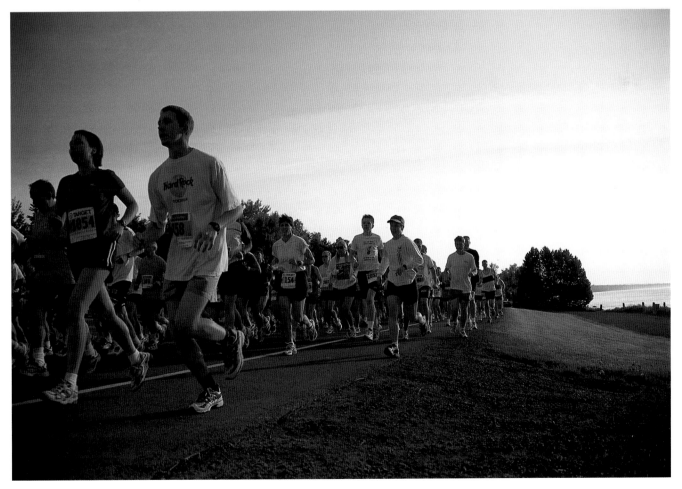

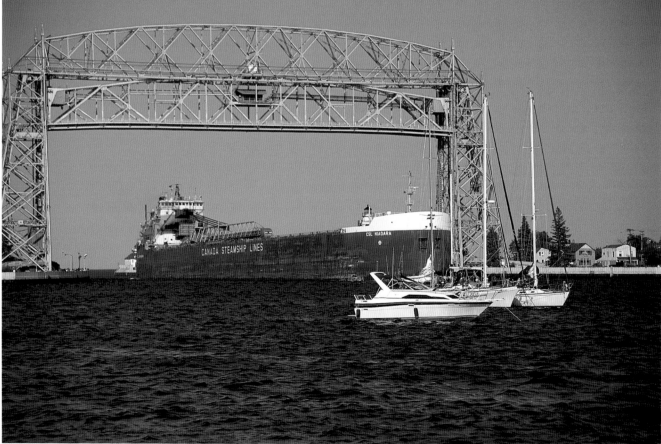

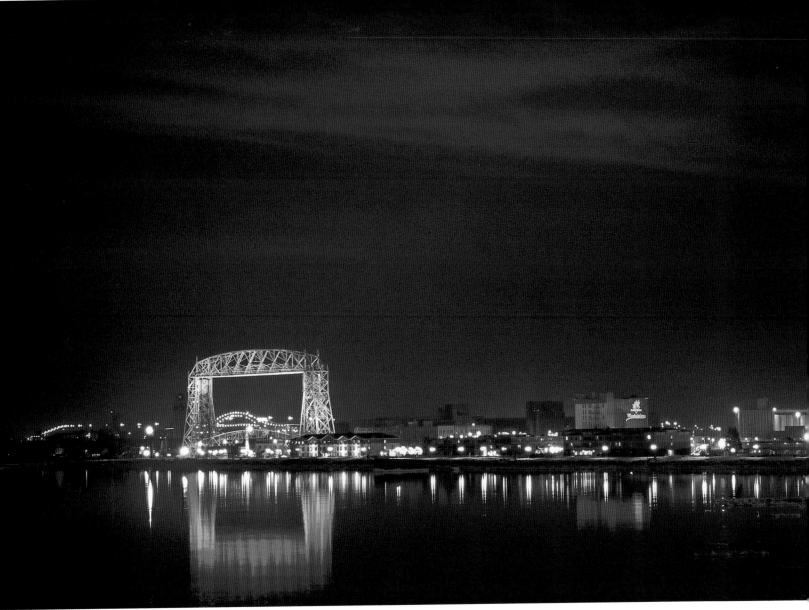

Both photos: *Duluth's*
the Lake Superior water
festivals in the country,

Facing page, both photos: *French explorer Sir Daniel Greysolon Sieur duLhut traveled across Lake Superior to the place that would become his namesake, Duluth, in 1679. Fur traders soon followed, but discovery of rich mineral deposits and plentiful forests nearby quickly switched the developing city's focus to taconite and timber. Once railroads were laid and the port was established, Duluth transformed into a commercial center. Today it is the top-volume port on the Great Lakes.*

Above: *Duluth's first aerial ferry bridge was built in 1905 and converted to an aerial lift in 1929.*

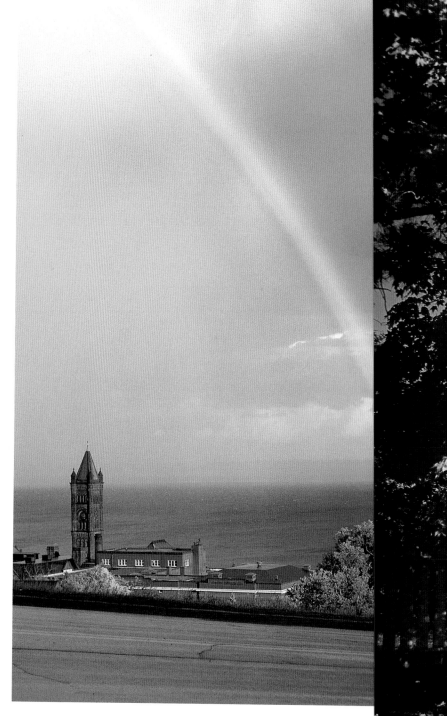

Duluth definitely seemed like the end of the rainbow for the town's ea
shipping. Today, thanks in part to the historic downtown area and La
industries in drawing dollars to the city.

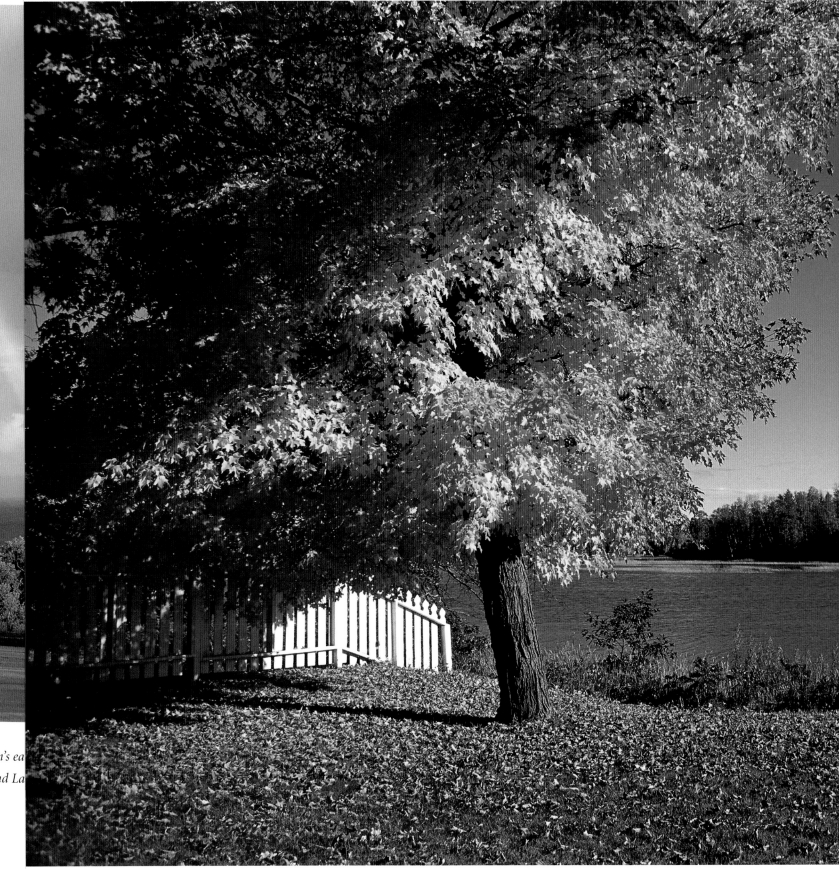

The Mississippi River heads north for a time before turning south, past Grand Rapids, where it is pictured here with peak fall colors on both of its banks.

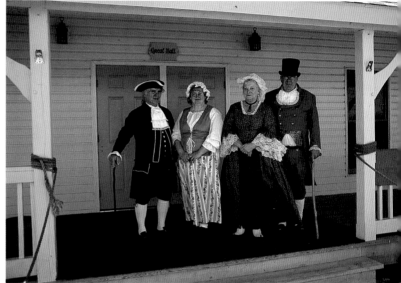

On the outskirts of Grand Rapids, White Oak Fur Post is a popular stop. Here, well-versed inhabitants in period dress tell visitors all about the re-created 1798 fur-trading post.

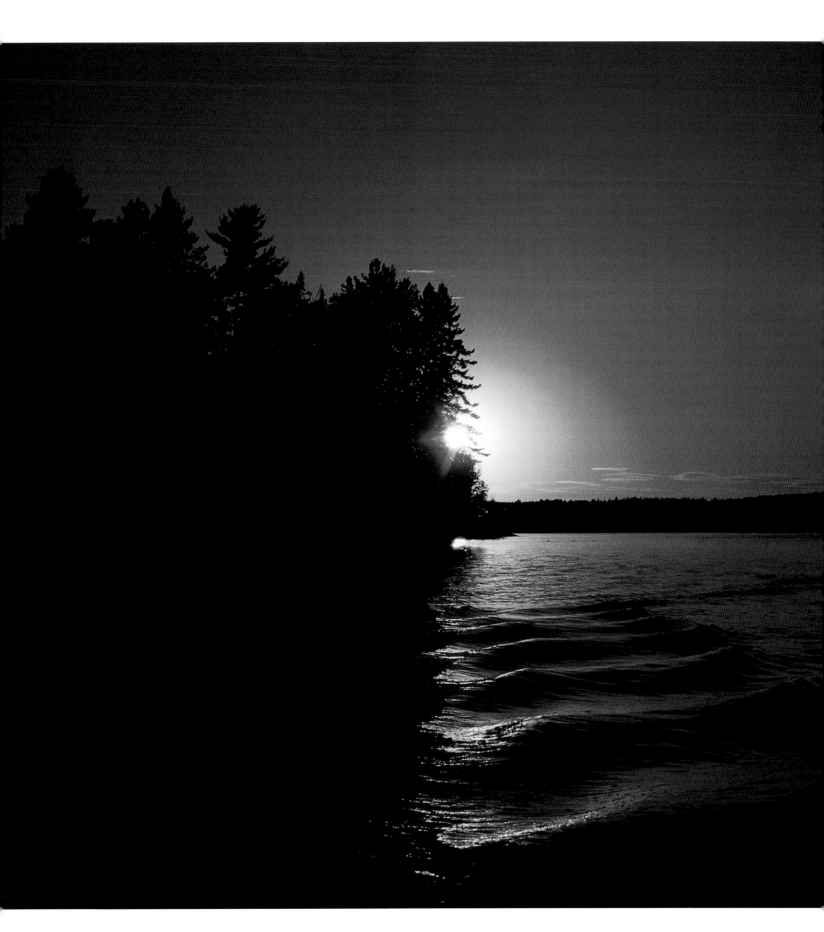

The sun sets over the rolling waves of Farm Lake, near Ely. Ice generally starts to disappear off Minnesota lakes during the first part of April in the south and in the first days of May in the north.

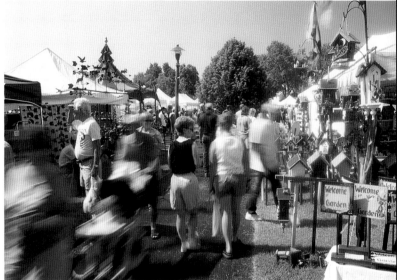

Above, both photos: *More than two hundred exhibitors set up in Ely's Whiteside Park for the Blueberry Arts Festival. The fruit is generally ripe during the last weekend in July, and there are plenty of blueberry-related foods like pancakes, muffins, and pies. The three-day festival drives Ely's population from four thousand up to about fifty thousand.*

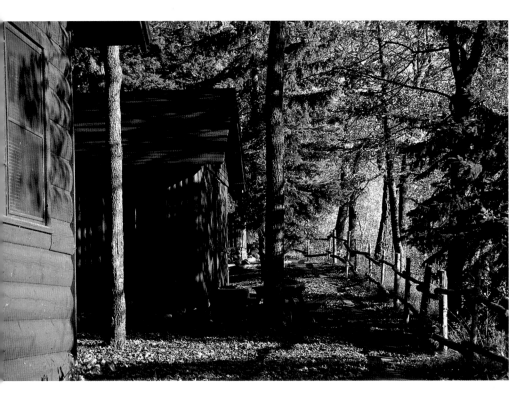

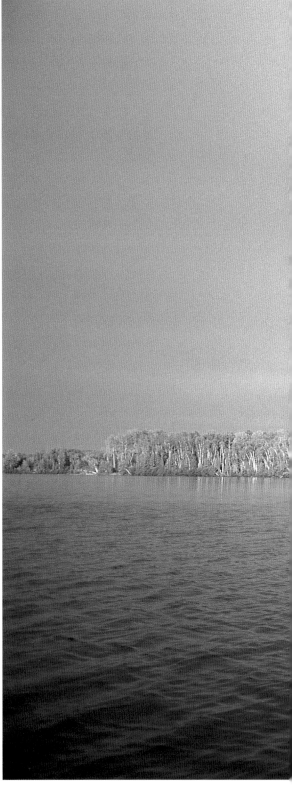

Both photos: *In Minnesota, everyone knows someone who owns a cabin "Up North." Towns in the heart of lake country, such as Brainerd, Park Rapids, Detroit Lakes, and Alexandria, draw visitors during all seasons.*

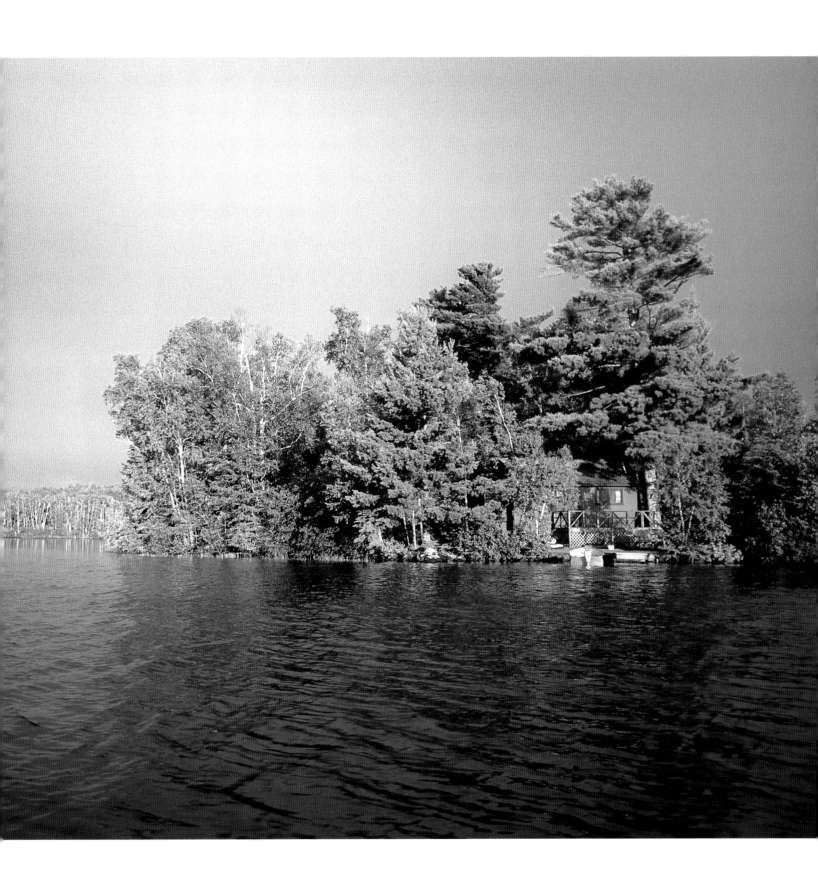

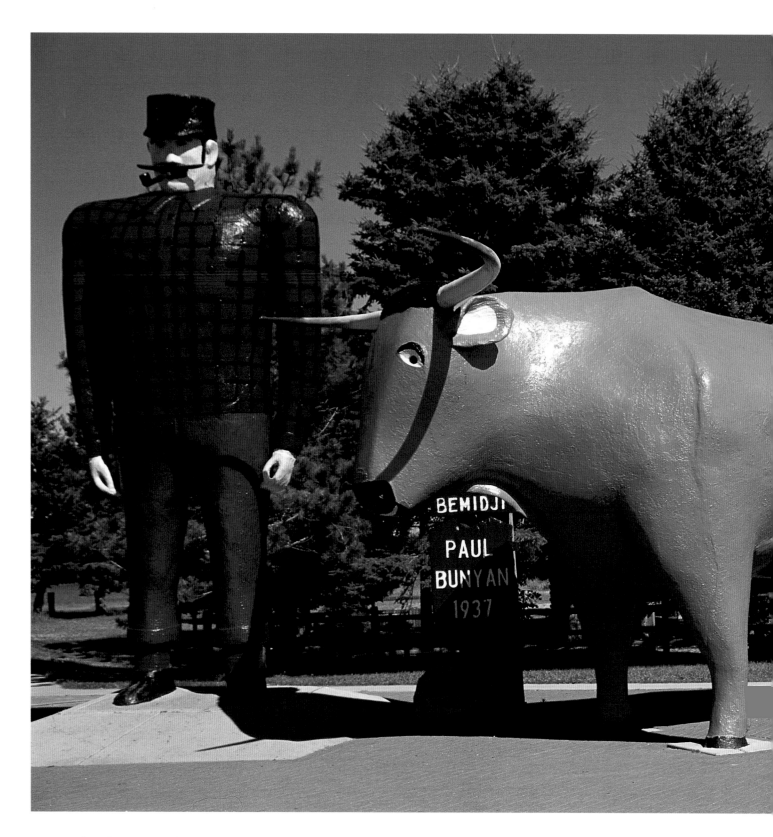

Statues of Paul Bunyan and his trusty friend, Babe the Blue Ox, mark the birthplace of America's legendary logger in Bemidji. The 7.5-ton pair was built in 1937.

The Aitkin Fish House Parade, held the day after Thanksgiving, features up to eighty houses, and, based on past parade winners, the odder the presentation, the better.

Both photos: Mom-and-Pop shops in Northern Minnesota's lake country are a part of both local life and visitor vacations.

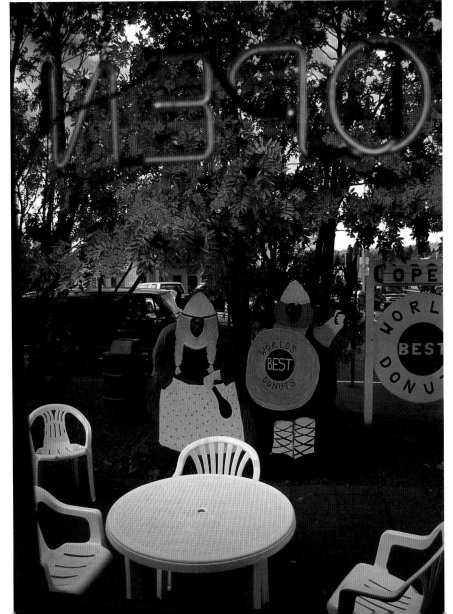

Both photos: *The annual opening of the World's Best Donut Shop in Grand Marais is a true sign of the summer's beginning. More than eighty patrons leave their mugs in the shop, which rewards them with savings on an already economical cup of coffee.*

A common Minnesota scene: the already intricate surface of a birch tree enhanced by lichen.

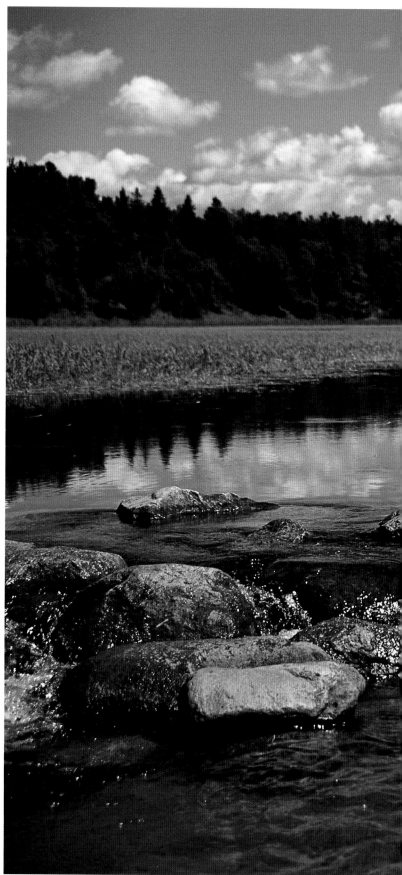

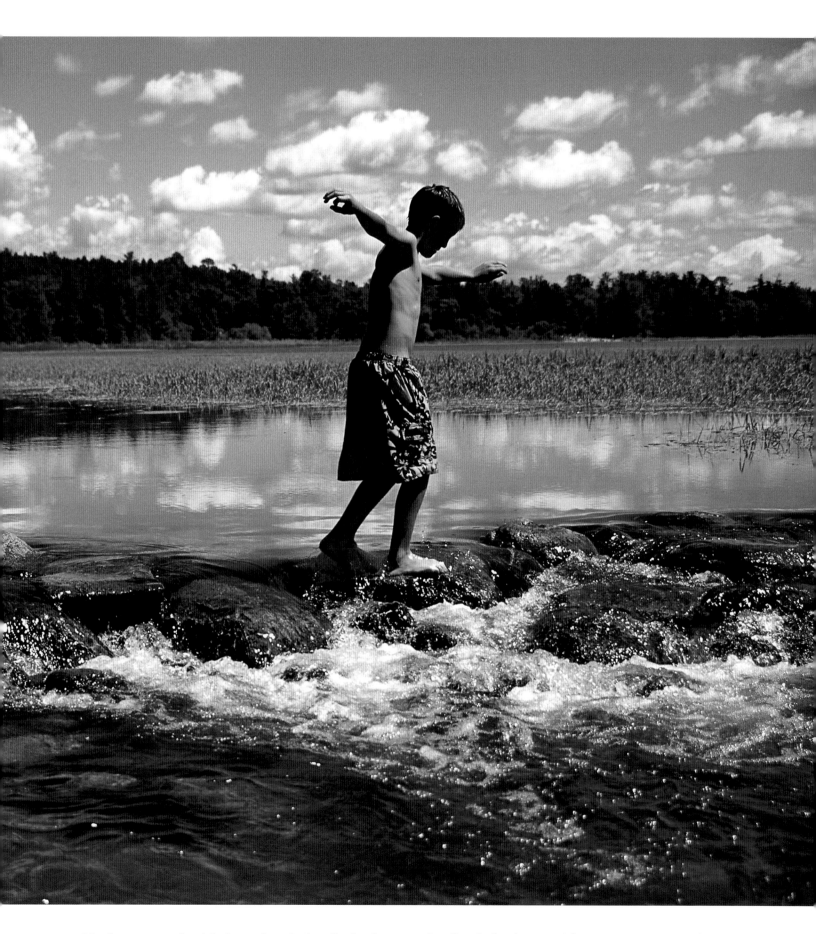

Nearly everyone who visits Itasca State Park walks the short, paved trail to the headwaters of the Mississippi River, and many brave the precarious walk across the rocks in the slow-moving current.

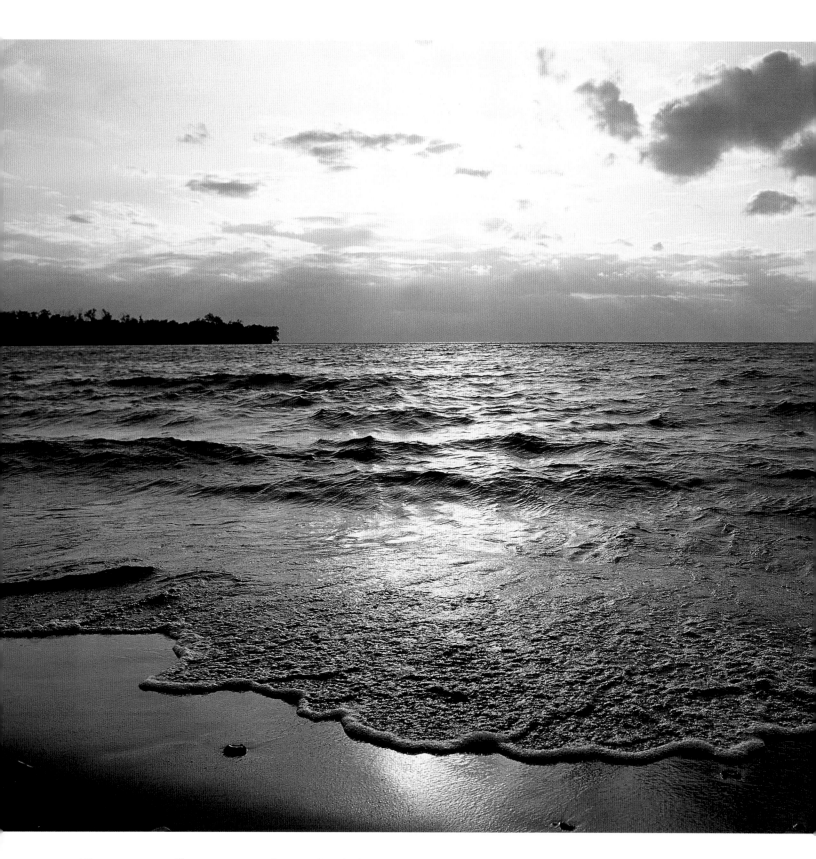

The sun sets on Mille Lacs. At more than two hundred square miles in area, Mille Lacs is the state's second-largest inland lake.

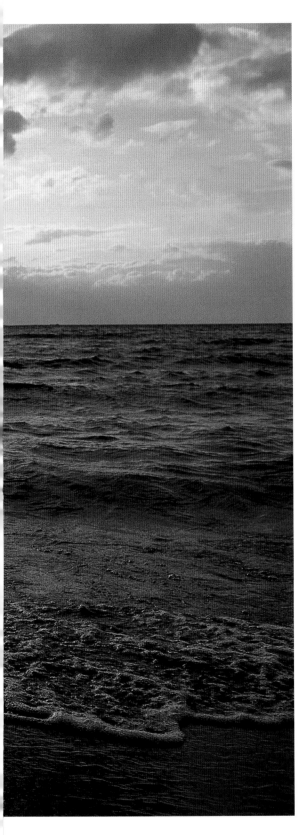

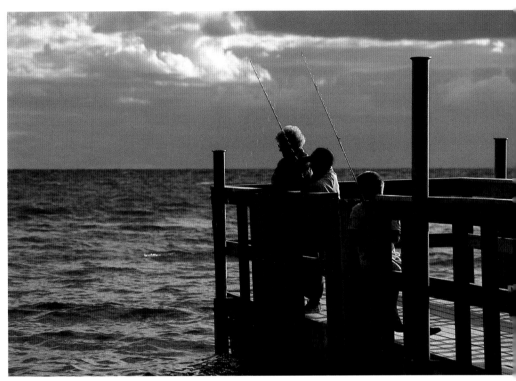

Father Hennepin is the only state park on Mille Lacs, and its fishing piers are popular spots for anglers.

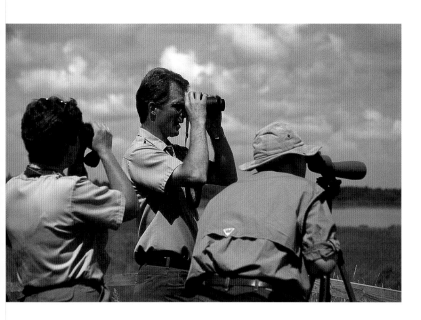

Both photos: *Tweets, chirps, and caws punctuate the air at the Thief Lake Wildlife Management Area in northwestern Minnesota. Tourists with binoculars and field guides tread softly on the observation mound overlooking reedy, shallow wetlands of Thief Lake. Established as a refuge in 1930, the area's fifty-three thousand acres are home to more than two hundred bird species and sixty mammal species.*

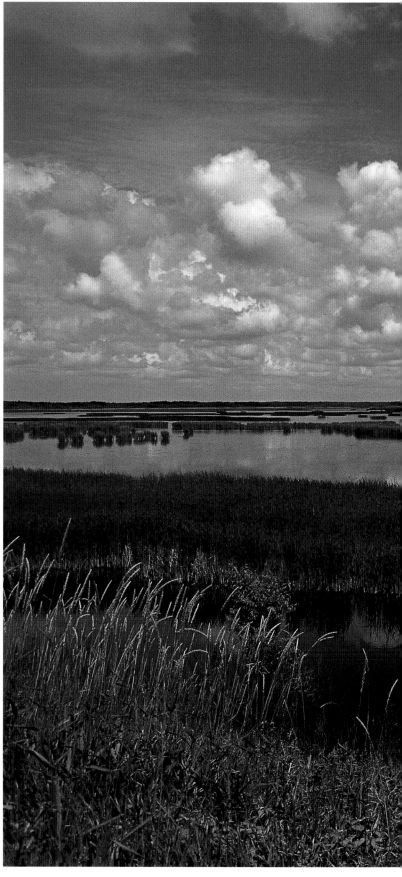

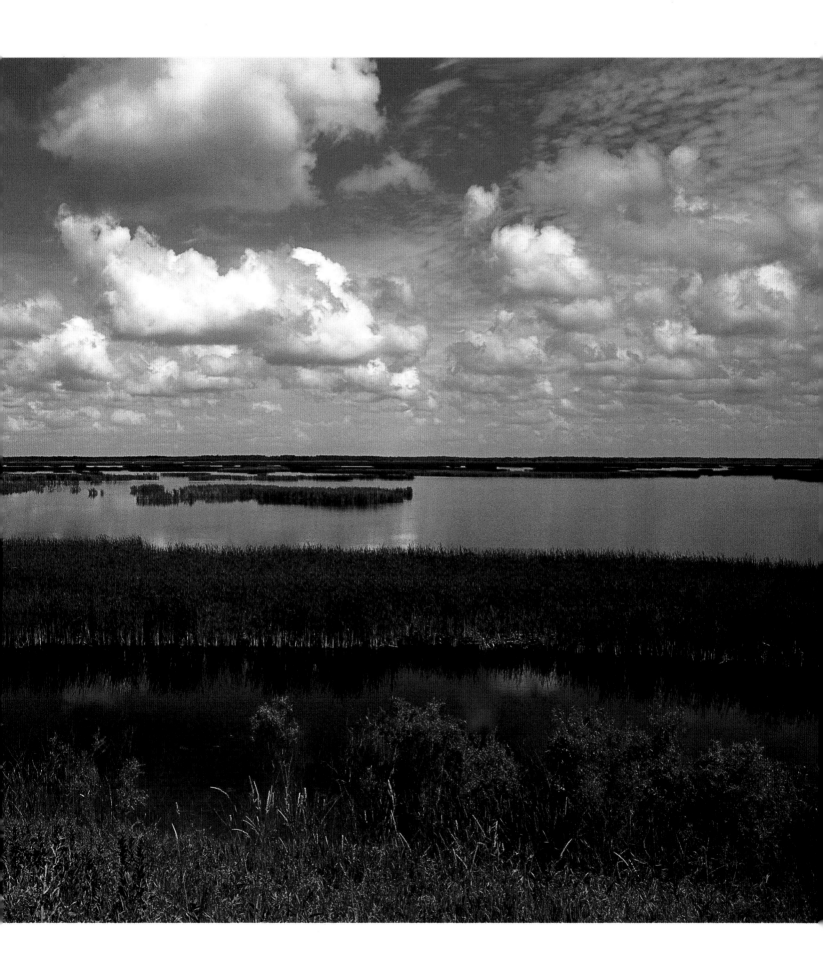

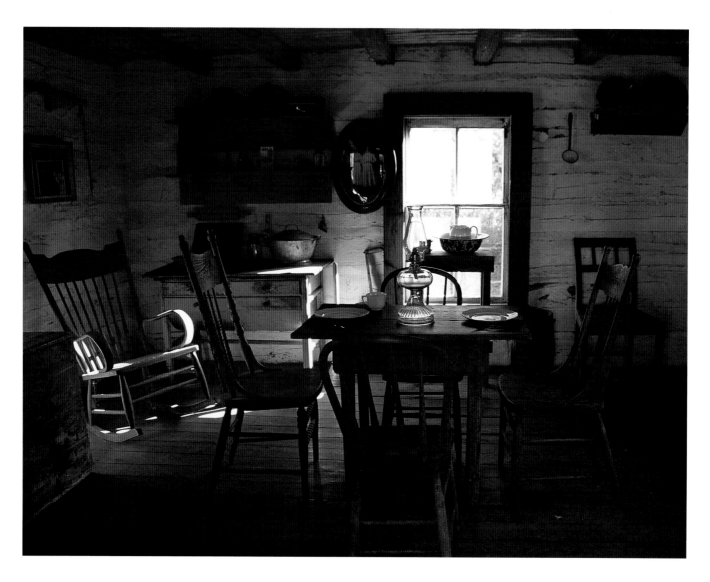

Both photos: *Glimpses of the way things were more than one hundred years ago add to the many traditional outdoor offerings at Old Mill State Park in northwestern Minnesota.*

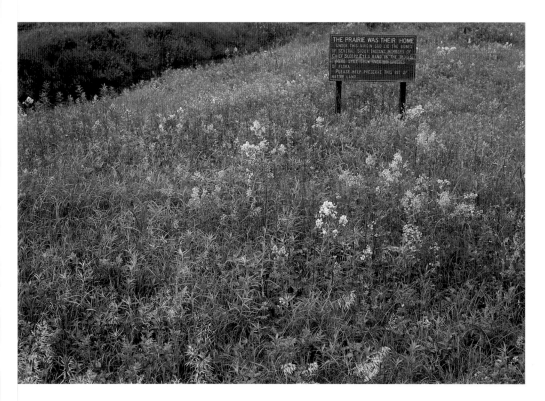

Known as a peaceful leader, Chief Sleepy Eye died in 1860 after a long life spent largely in the state's southern prairielands. It's been said that the Minnesota Uprising of 1862, the only battle ever fought on Minnesota soil in recorded history, would never have happened if Sleepy Eye had still been alive.

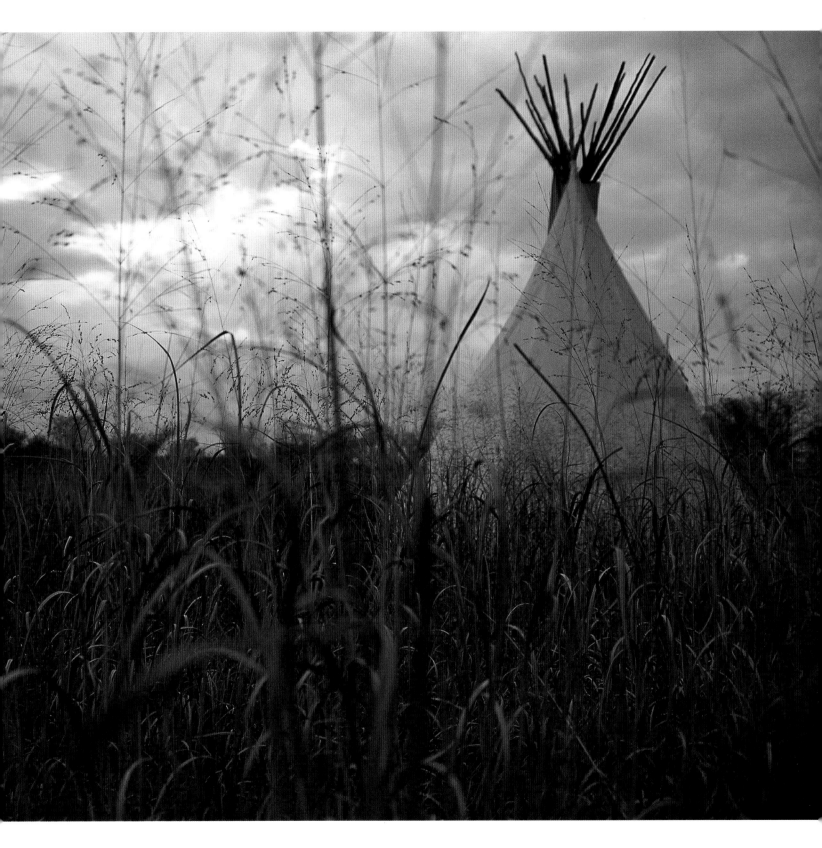

Upper Sioux Agency is the only state park in Minnesota where you can spend the night in a tipi. The picturesque campsites are a nod to the American Indian history of this beautiful stretch of land, where Yellow Medicine River meets the Minnesota.

Big Stone Lake State Park preserved grasses like these—many others in west-central Minnesota were turned into farmland. The park's namesake is the source of the Minnesota River.

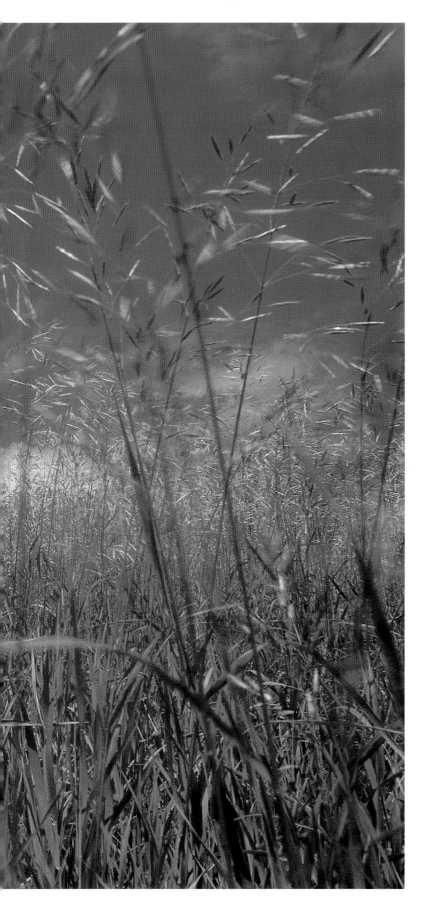

An absence of trees and abundance of wild grasses made sod homes a natural choice for pioneers who settled on the rolling prairies of southwestern Minnesota. This 1880s replica is a one-room bed and breakfast about half an hour's drive from Walnut Grove.

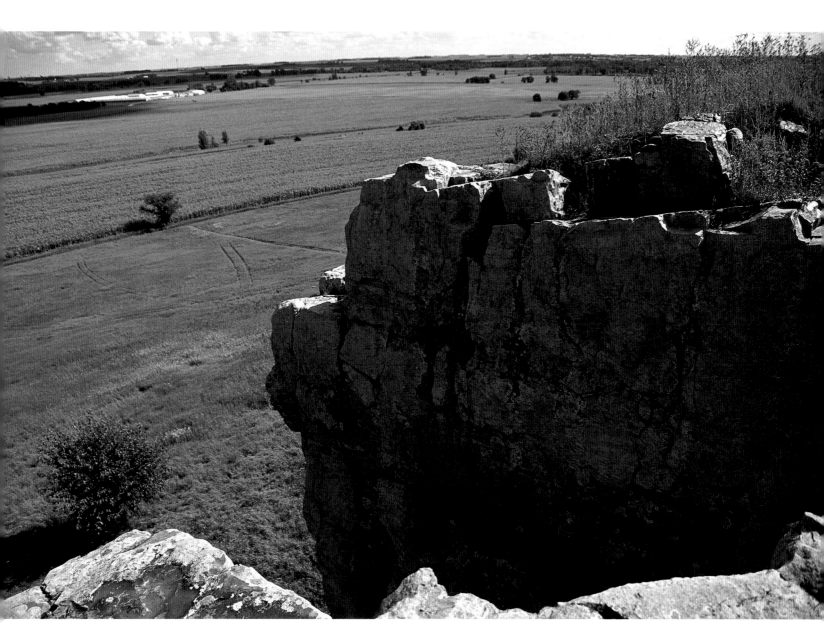

Above: *Blue Mounds State Park sits on a large mound that ends in one-hundred-foot-tall Sioux quartzite cliffs. Some of the scenic park's other prairieland attractions include wildflowers, birds, and a bison herd.*

Right: *About eight thousand years ago, natives etched characters into sheets of hillside Sioux quartzite in what is now southwestern Minnesota. Thought to make up maps, religious teachings, and possibly parables, Jeffers Petroglyphs comprise a couple thousand symbols still frozen in about 750 feet of rock.*

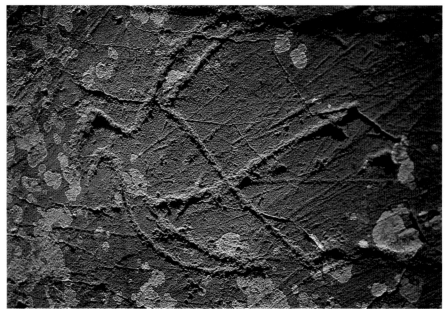

Pipestone's 1888 Calumet Inn is experiencing its second heyday as one of the city's twenty listings on the National Register of Historic Places.

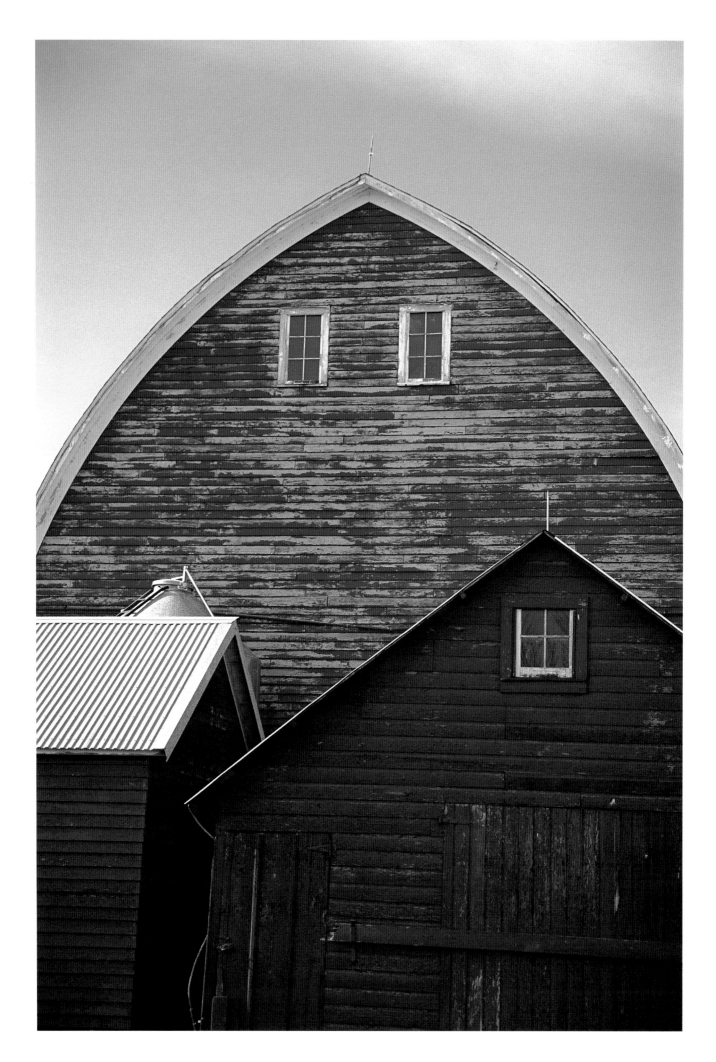

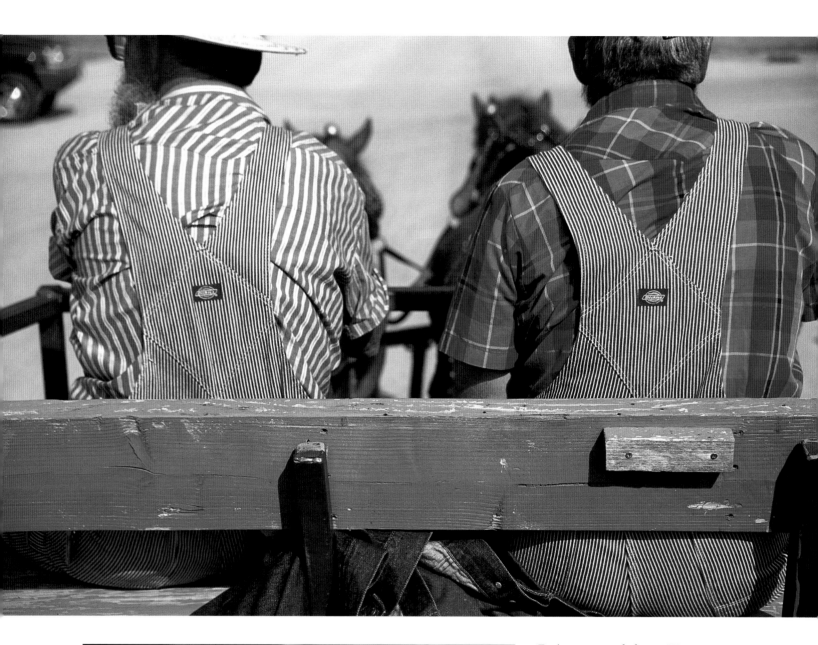

Facing page and above: *No matter how much things change, there's still plenty of evidence of the past here in Minnesota. Oftentimes, old meets new. A weathered barn like this one, for example, can hold state-of-the-art farming equipment. And though the two men shown above are abundantly familiar with current farm life, this horse-drawn wagon ride was part of a small-town festival where folks get a glimpse into farming's history.*

Left: *Rows of mailboxes at the turnoff to a shared country road are common in rural Minnesota.*

This golden field of soybeans is a common sight in Minnesota since the crop, on the whole, brings Minnesota farmers more money than any other agricultural product.

The sun sets behind a farm in Pine County. Driving on Minnesota's back roads, you're likely to encounter this pastoral scene.

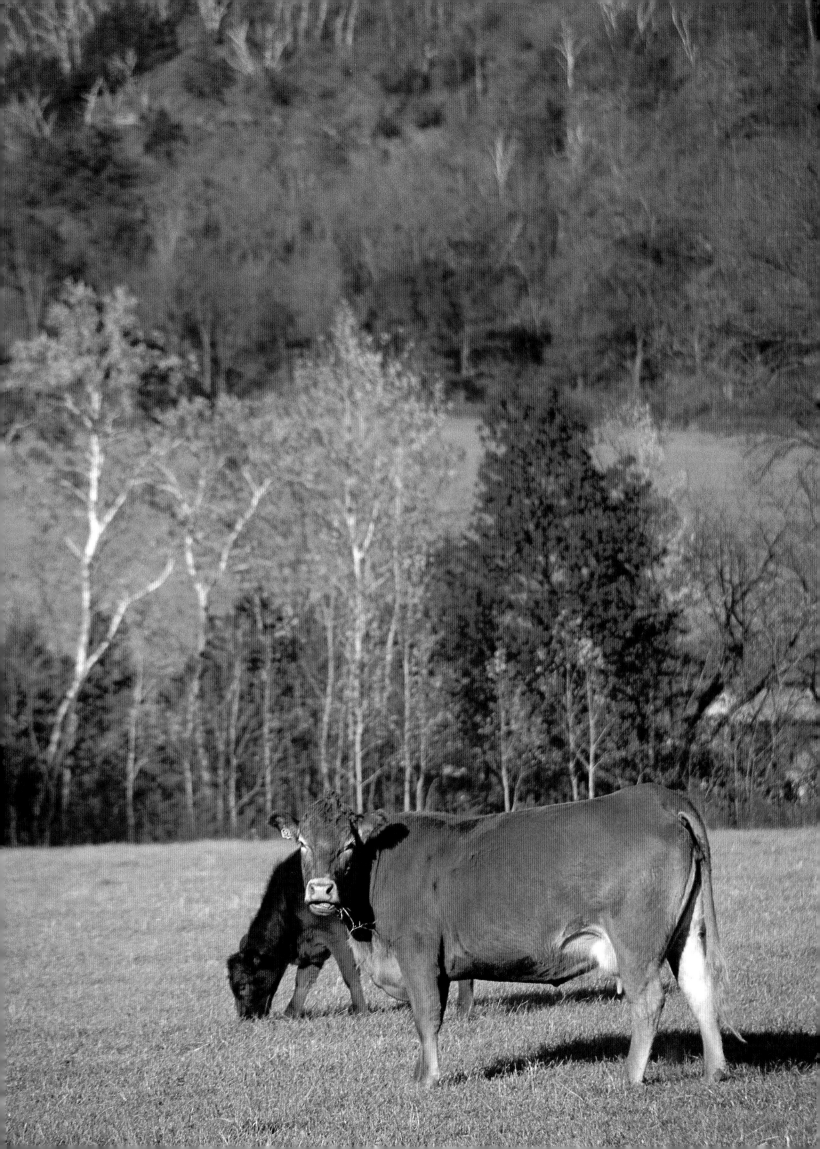

Facing page: *These cows live in Minnesota's Houston County, part of the dairy region that spills from the center of the state down to the southeast corner.*

Left: *Guests can cuddle the baby goats at Dancing Winds Farm, a twenty-acre sustainable farmstead that operates as a goat dairy, cheesemaking facility, and bed and breakfast.*

Below: *Calves, chicks, lambs, and piglets are a part of everyday life in rural Minnesota.*

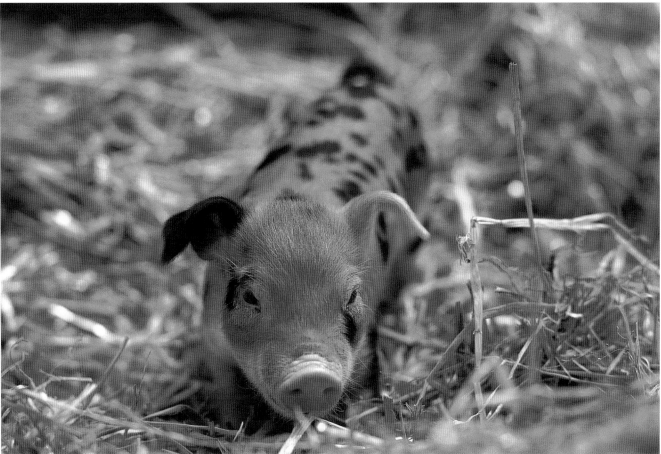

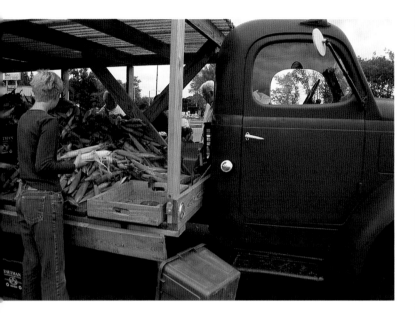

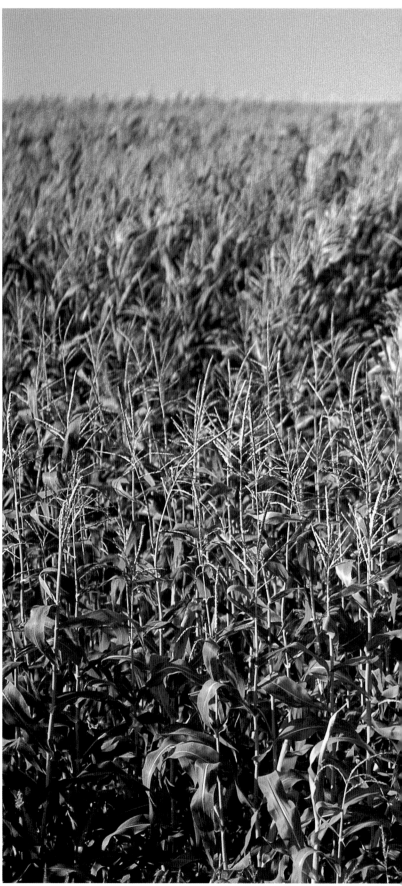

Above, both photos: *Roadside stands are one of the hundreds of places where consumers can buy produce direct from Minnesota farmers—everything's guaranteed homegrown, fresh picked, and well priced. If it's dinnertime and no one is in sight, you're trusted to leave the correct amount for your purchase. This woman paid the grower directly when she bought corn straight from his truck near Alexandria.*

Right: *The number of Minnesota farmers dwindled from 118,000 in 1975 to 79,000 in 2000. Production, however, has remained surprisingly constant. Larger farms, new seed varieties, and highly efficient equipment are just some explanations for the consistency.*

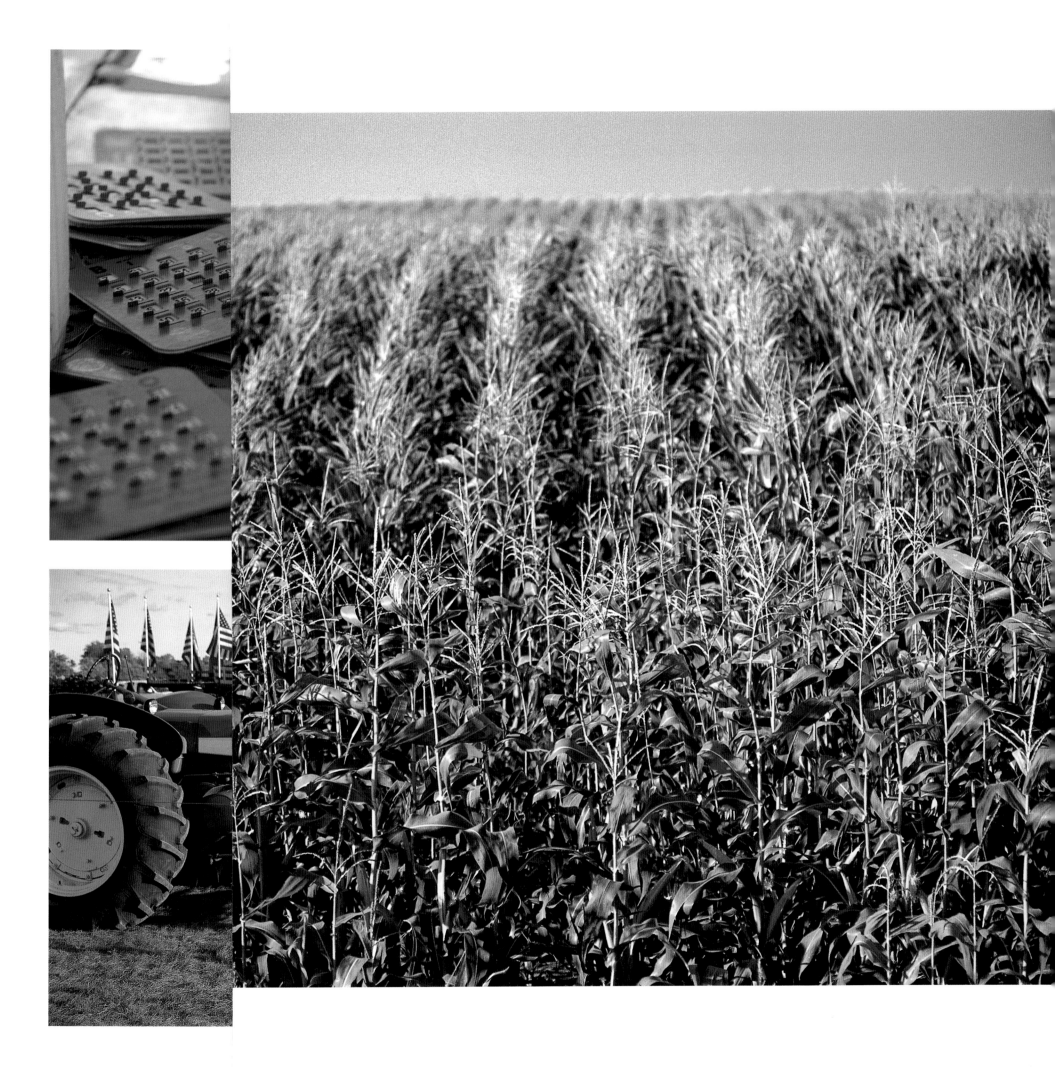

Darrin Nelson's red Angus cow-calf t[...]
Farming is a 120-year-old tradition [...]
farm north of Benson.

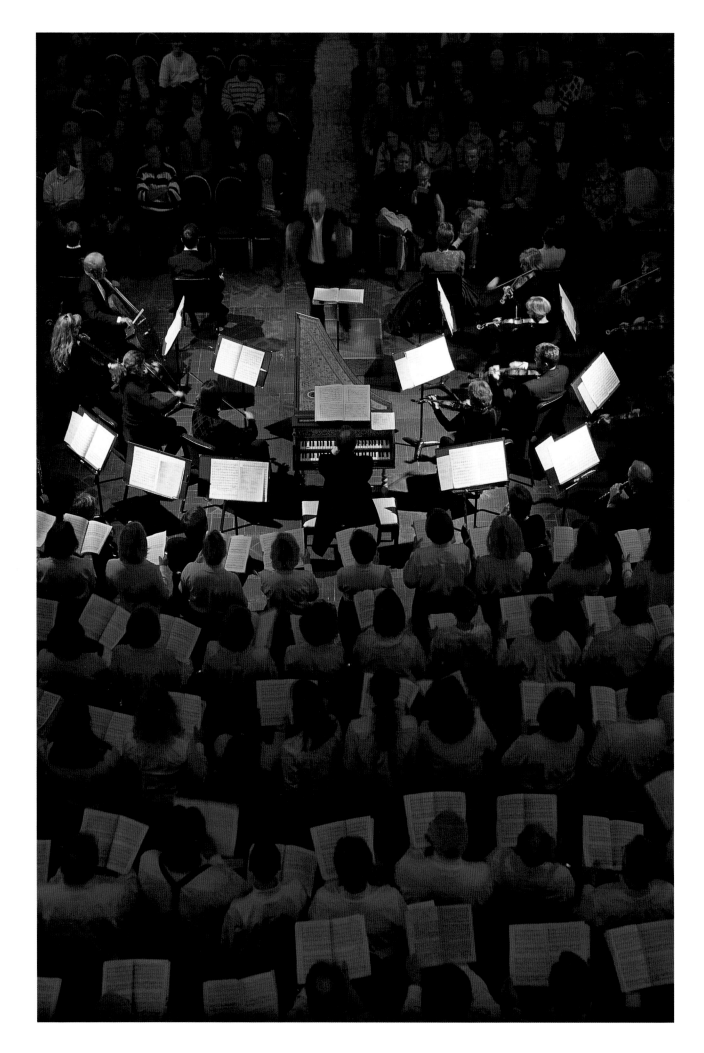

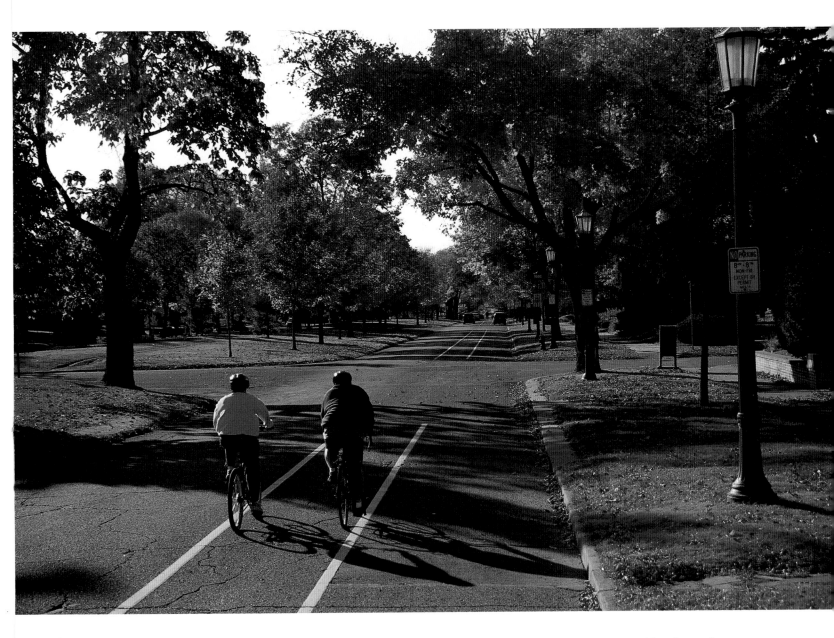

Facing page: *The Saint Paul Chamber Orchestra, pictured here at Saint Paul's Landmark Center, is considered one of America's premier chamber orchestras.*

Above: *Summit Avenue is the country's longest span of original residential Victorian architecture. The homes, along with the grassy boulevard, make it one of Saint Paul's most picturesque streets.*

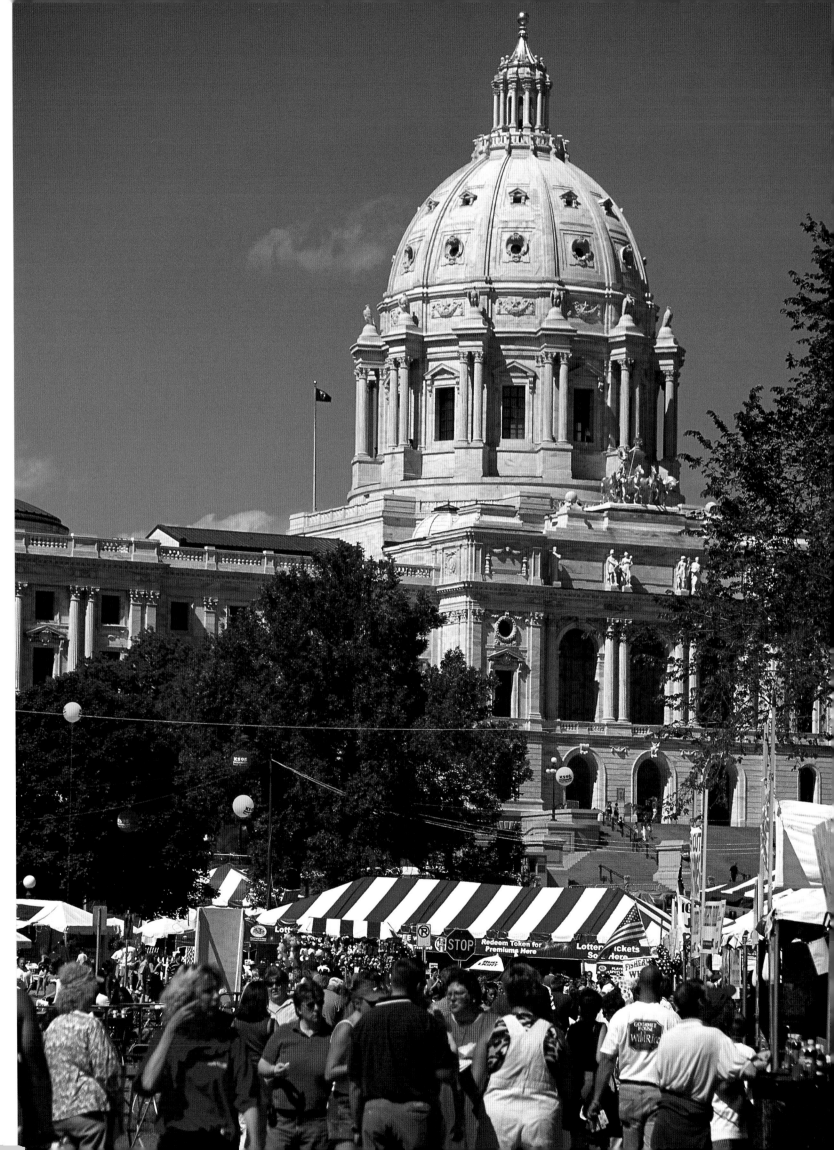

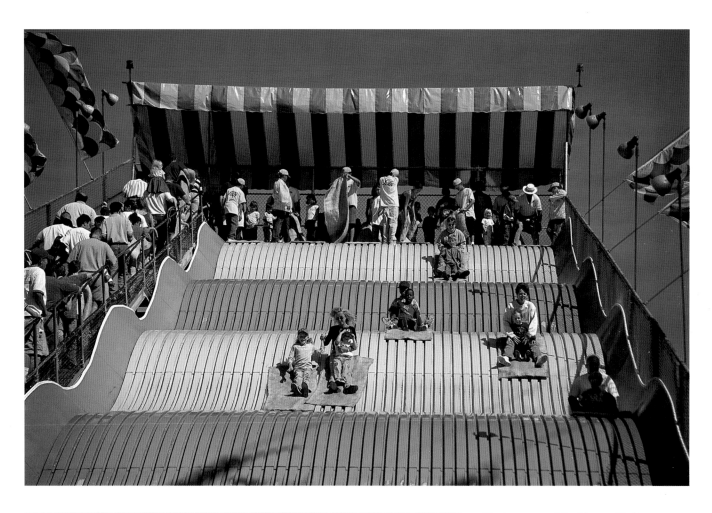

Facing page: *The Taste of Minnesota, the state's largest free event, takes place over July 4 in downtown Saint Paul.*

This page, both photos: *Since its construction in 1968, the fifty-foot giant slide has been one of the most popular rides at the Minnesota State Fair. Minnesotans come by the thousands to the "Great Minnesota Get Together" for the rides, exhibits, and, of course, the food.*

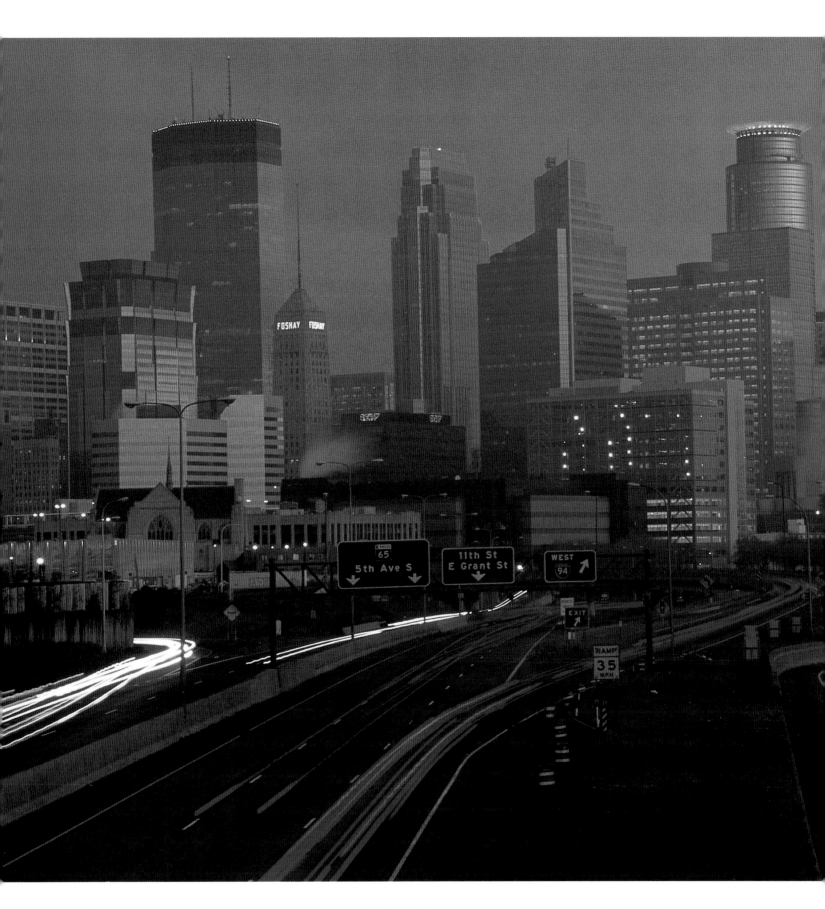

The IDS Tower (left), the Wells Fargo Center (middle), and 225 South Sixth (right) punctuate this early morning view of the Minneapolis skyline. The IDS is the city's tallest building at 775 feet, though the aforementioned two runners-up are just one and two feet shorter.

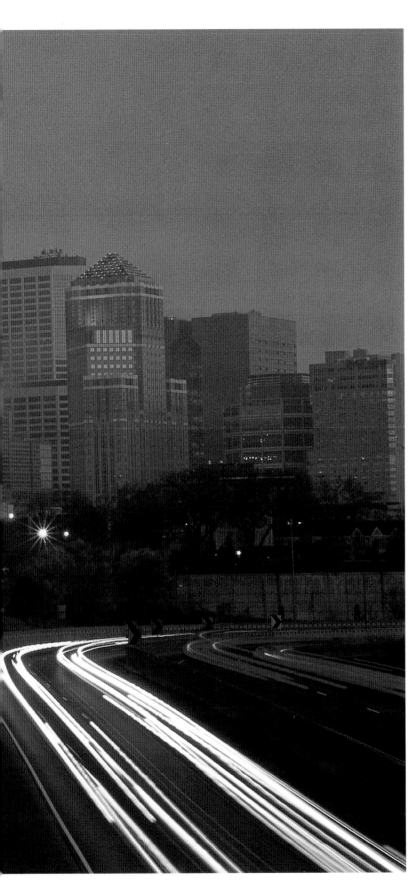

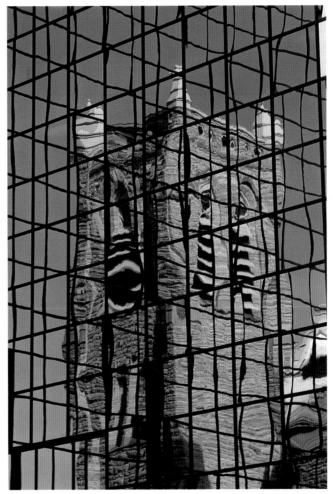

Westminster Presbyterian Church is reflected in the glass panes of the modern building at 1221 Nicollet Mall.

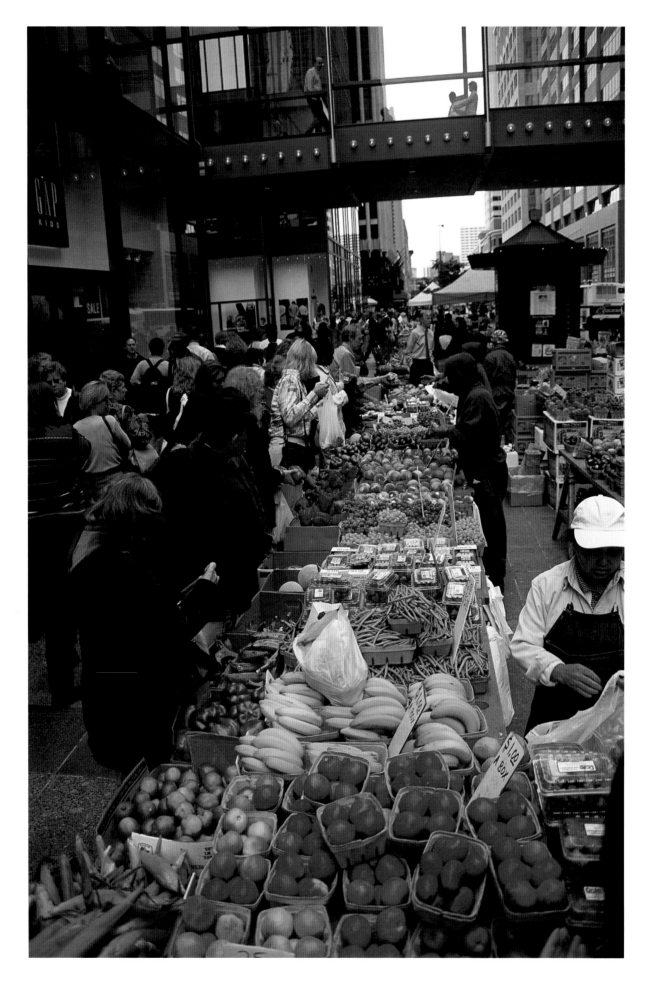

Nicollet Mall swarms with shoppers and vendors Thursdays and Saturdays, May through October, at the Minneapolis Farmer's Market.

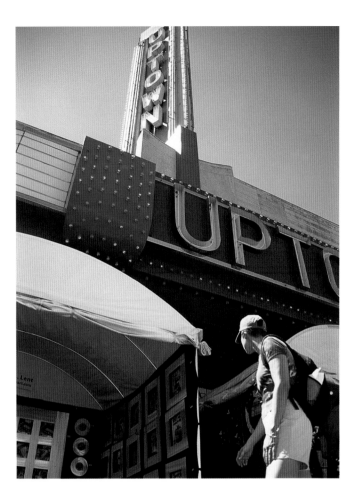

Left: *Nearly half a million art lovers descend upon Minneapolis's bohemian Uptown area for the annual Uptown Art Festival. The festival features arts and crafts vendors from across the nation and around the world.*

Below: *On winter evenings over the holiday season, downtown Minneapolis's Nicollet Mall is a mass of twinkling floats during the Holidazzle Parade. Spectators crowd the streets and the overhead skyways to watch what's become the city's holiday harbinger.*

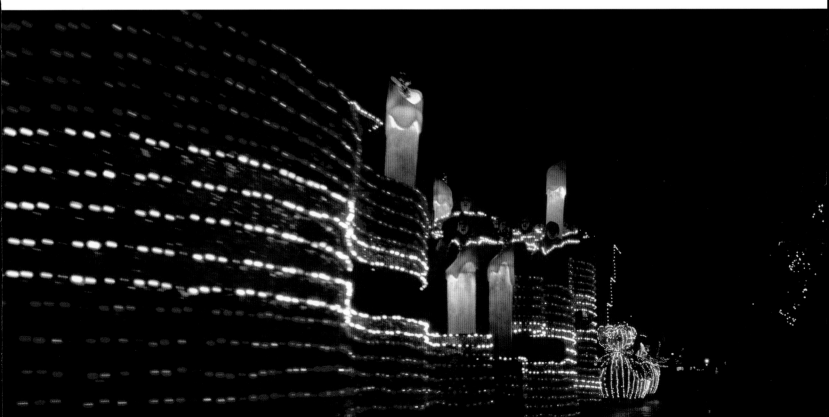

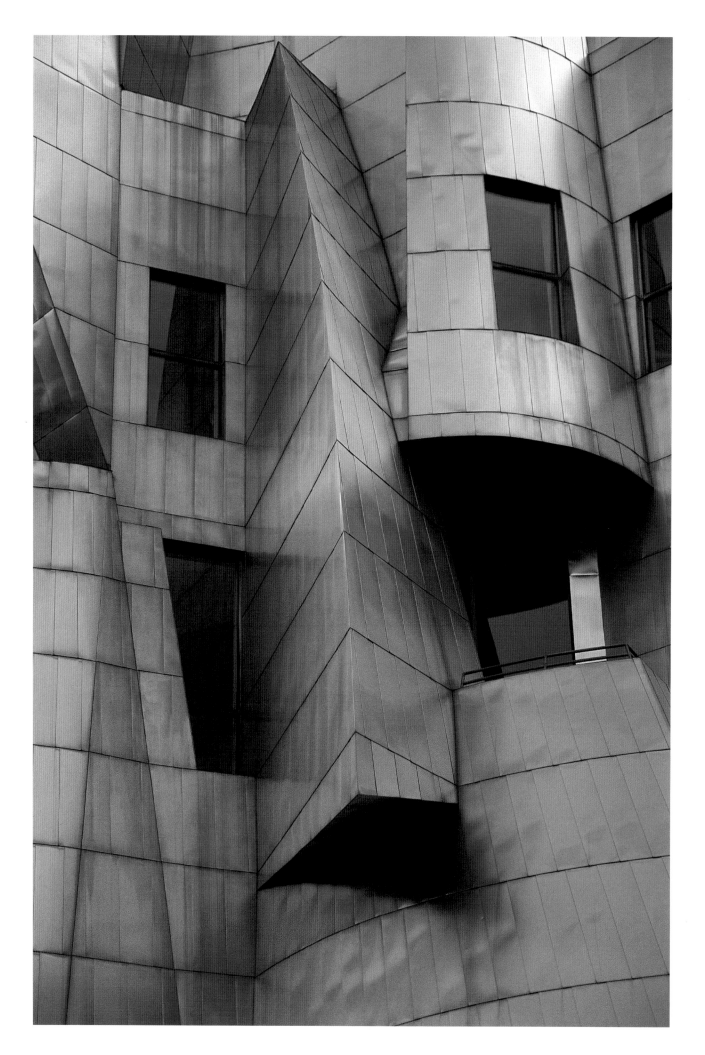

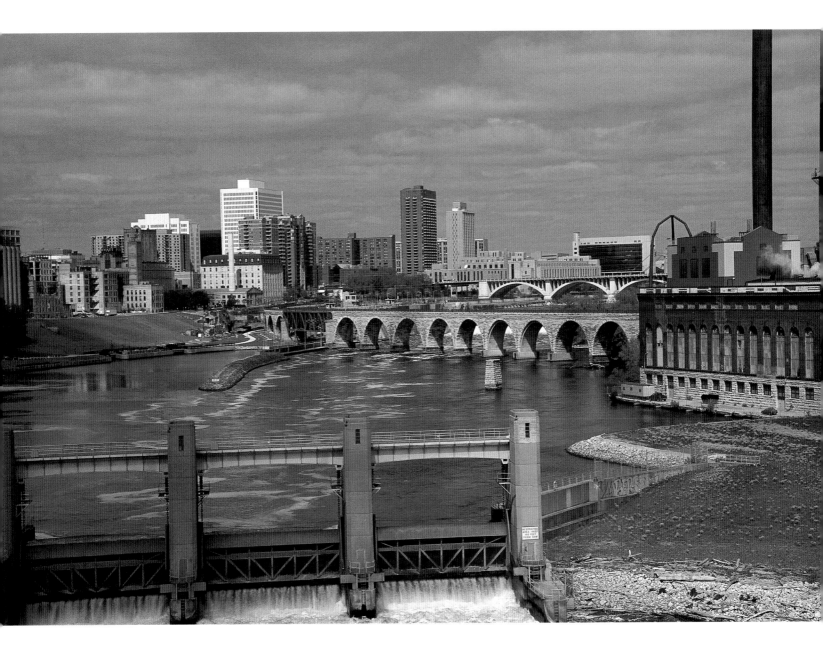

Facing page: *A work of art in its own right, the brushed stainless steel Weisman Art Museum, designed in 1993 by Frank Gehry, sits along the east bank of the Mississippi River on the University of Minnesota's Minneapolis campus.*

Above: *Saint Anthony Falls, the only falls on the Mississippi River, provided essential water power for Minneapolis's early mills. The historic Stone Arch Bridge once shuttled trains full of flour across the river. Today, pedestrians and bikers use the bridge to cross between Saint Anthony and downtown.*

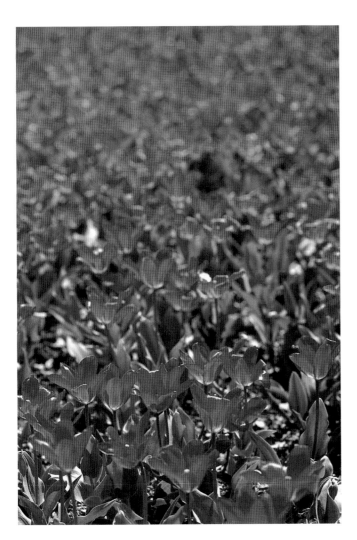

Facing page and below: *Minneapolis lives up to its nickname as the City of Lakes with twenty-two within the city limits, including Lakes Calhoun and Harriet.*

Left: *Tulips abound at the Lyndale Park Gardens along Lake Harriet in Minneapolis, just one of the state's many public gardens.*

The sun lowers through the branches of an apple tree at an orchard in the southeastern corner of the state.

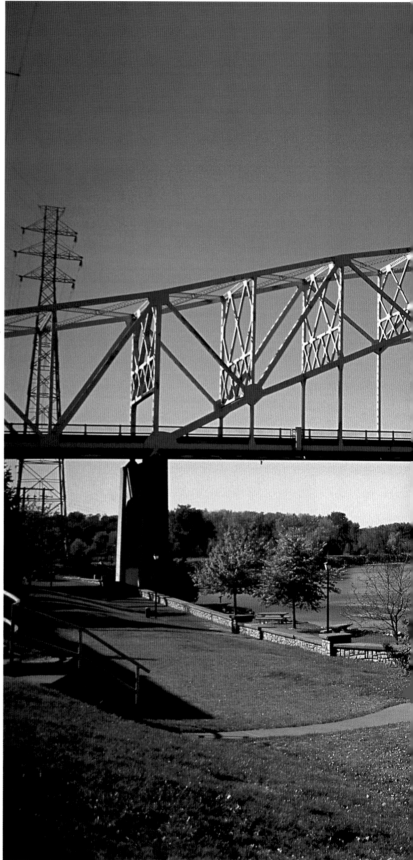

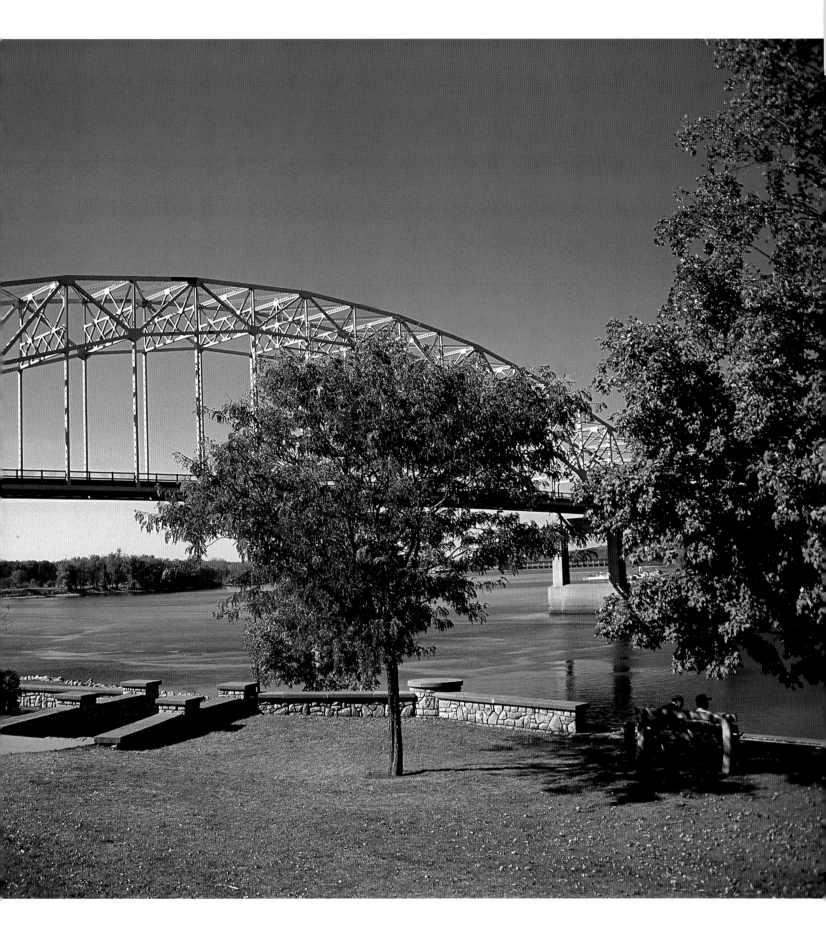

This bridge crosses the Mississippi in Hastings, a great getaway less than an hour from the Twin Cities.

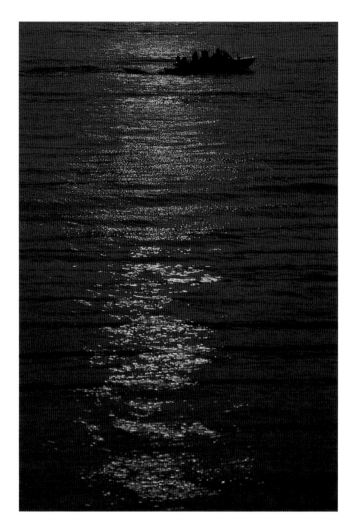

The Lower St. Croix River draws part of the border between Minnesota and Wisconsin. Designated a National Scenic Riverway, the river emerges from a valley and widens as it flows south into the Mississippi, making it ideal for everything from canoeing to tubing to boating.

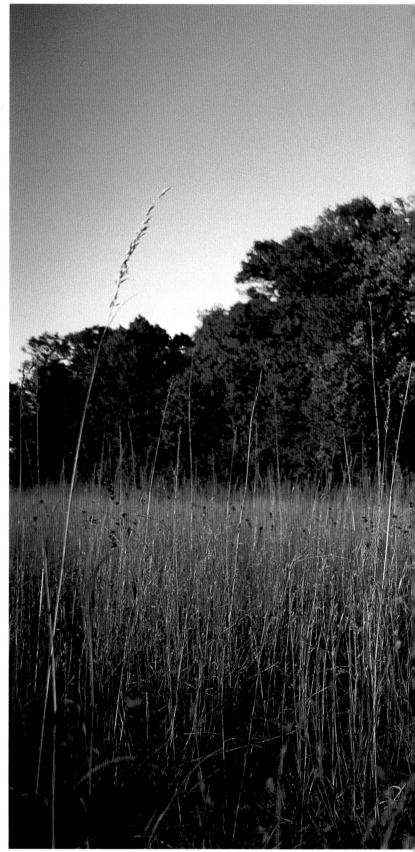

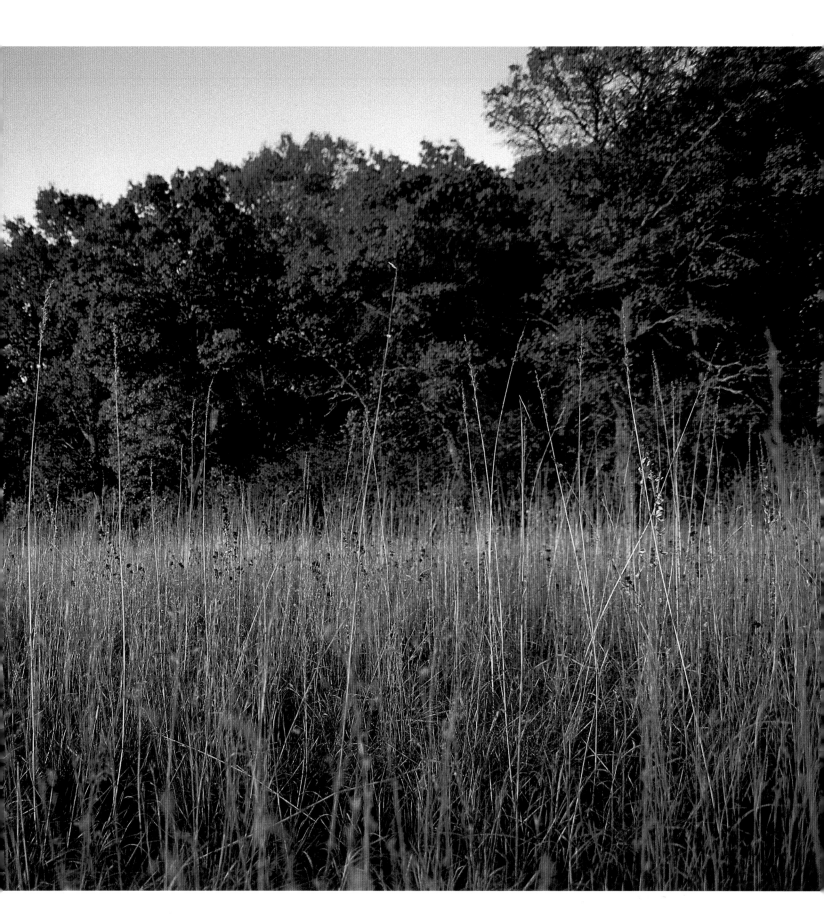

Wild River State Park sits at an area that transitions from pine and hardwood forest to oak savanna and prairie, affording stunning views both overhead and underfoot.

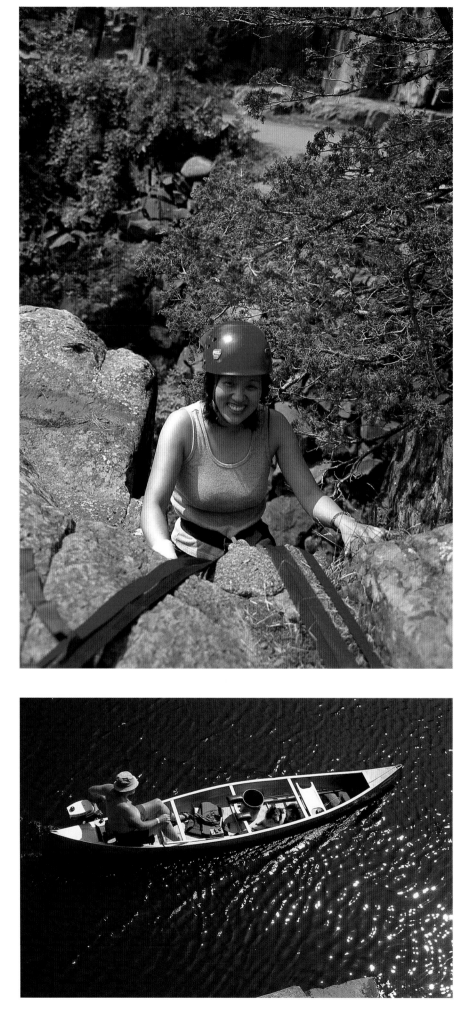

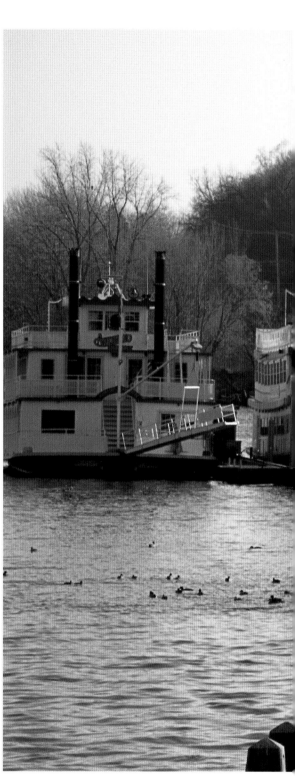

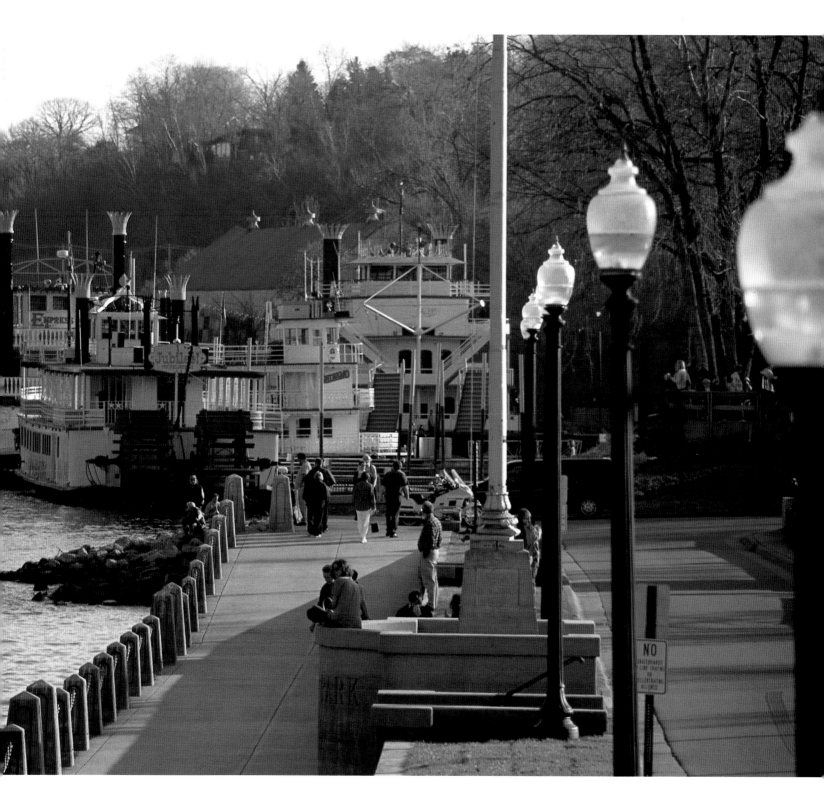

Facing page, both photos: *Rock climbers dot Interstate State Park's basalt cliffs, which, along with exposed lava flows and glacial deposits, document the area's formation over millions of years. The park's geology and opportunities for canoeing, kayaking, and hiking make Interstate one of the most visited state parks.*

Above: *In the nineteenth century, Stillwater flourished as a lumber town. Today it does as well as a tourist haven. Riverside strolls, architectural tours, and picturesque train trips are just a few reasons people still flock to this city on the St. Croix.*

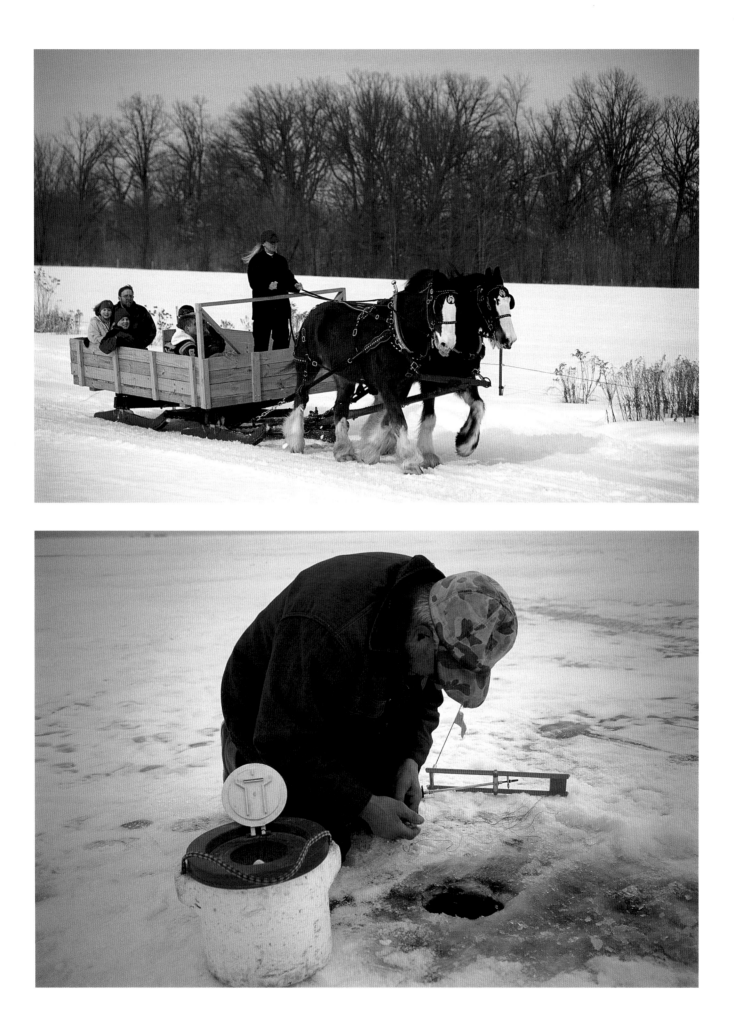

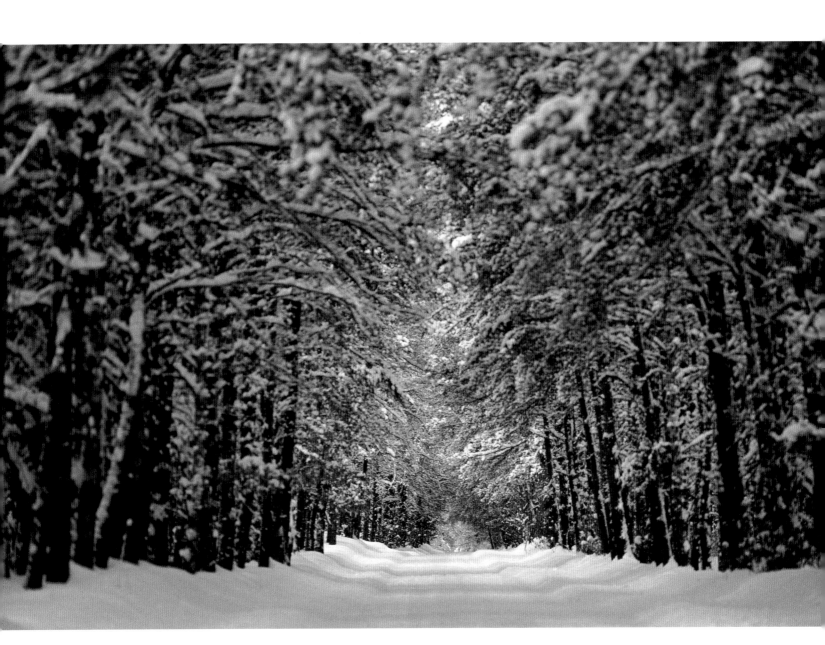

Facing page, top: *Sleigh rides may seem like a thing of the past unless you visit Maggie Kuusisto's farm near Taylor's Falls, where the clip-clop of horses' hooves and the jingle of sleigh bells are common sounds.*

Facing page, bottom: *Some ice fishermen simply sit, barehanded and shelterless, at a hole drilled into the ice. Others have ice houses that range from basic ten-foot-by-ten-foot structures to full-blown cabins with heaters, full kitchens, satellite TV, and even hot tubs.*

Above: *During winter walks through state parks, it's easy to find places where the crunch of your own footsteps is the only sound.*

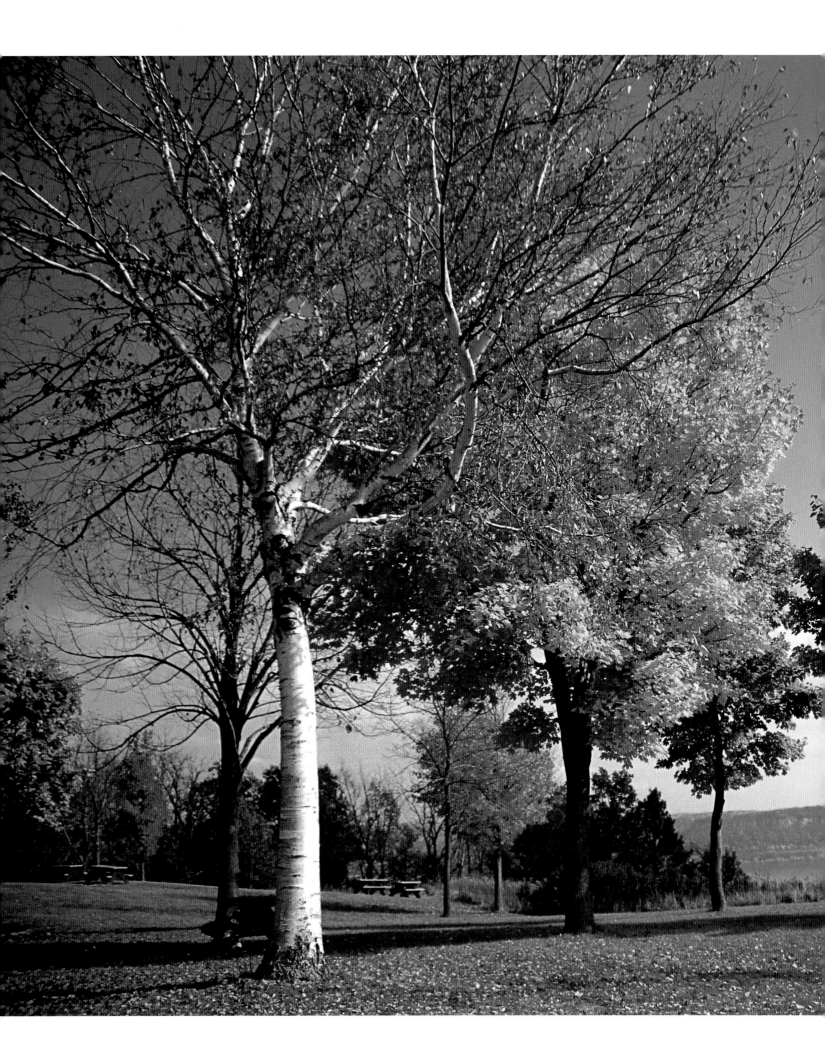

Frontenac State Park in southeastern Minnesota is a palette of complementary colors during fall, when orange leaves are set against the Mississippi River and a clear autumn sky.

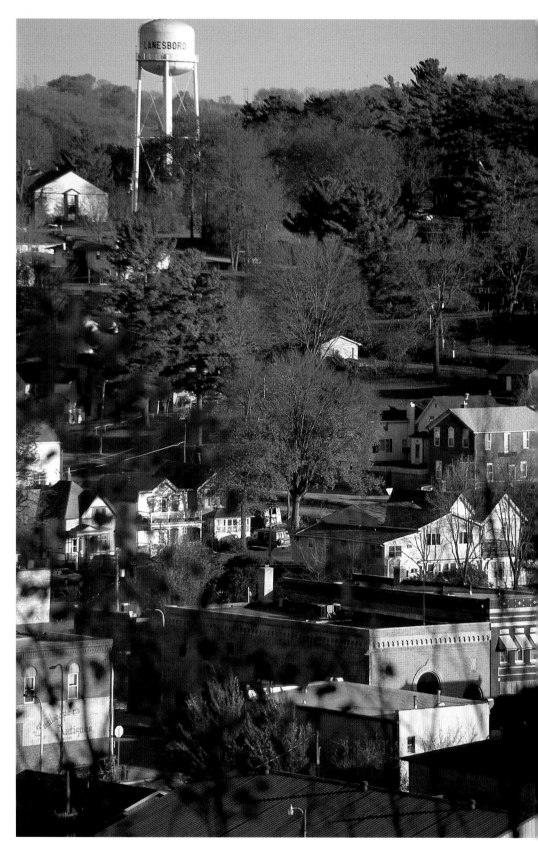

Above: *Red Wing's elegant St. James Hotel was built in the 1870s. Today restored to its original splendor, the hotel is a destination for guests from around the country.*

Right: *Lanesboro is the darling of Minnesota small towns. The historic downtown is situated on a thriving bicycle trail, and its art galleries, wine shops, and gift stores offer riders many reasons to dismount.*

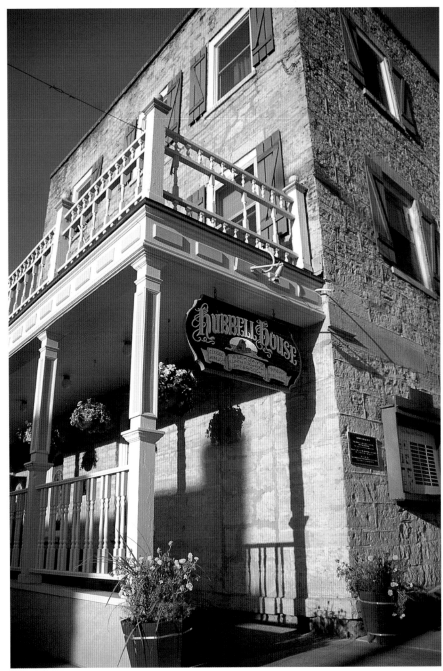

Both photos: *Mantorville's entire downtown, which includes the 1854 Hubbell House, is on the National Register of Historic Places. Paul Larsen's Memorabilia Antiques is one of the tourist-oriented businesses that sit alongside (or in) pieces of the town's history.*

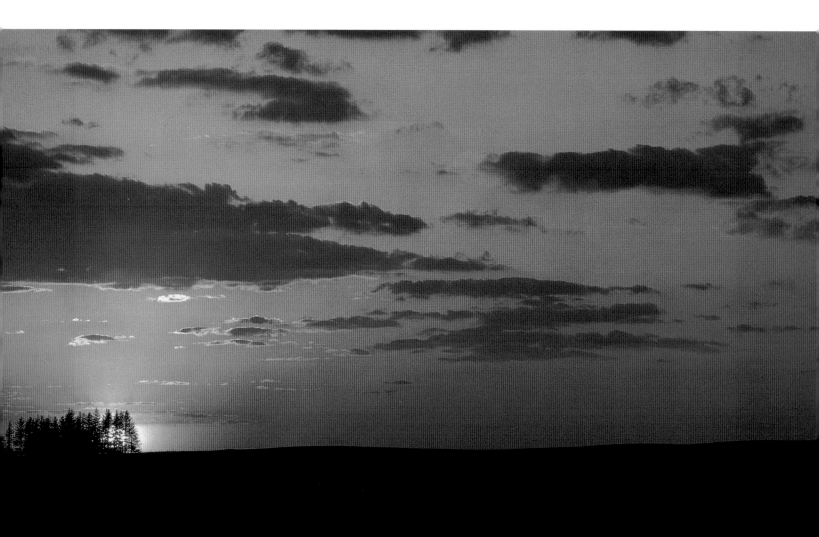

Above: *The sun burns down to the horizon on an empty stretch of road.*

Facing page, both photos: *Two families enjoy late-fall hiking, biking, and picnicking at Beaver Creek Valley State Park in southeastern Minnesota. Though there are plenty of outdoor options for the entire family, the park is well known for its clear, trout-filled streams.*

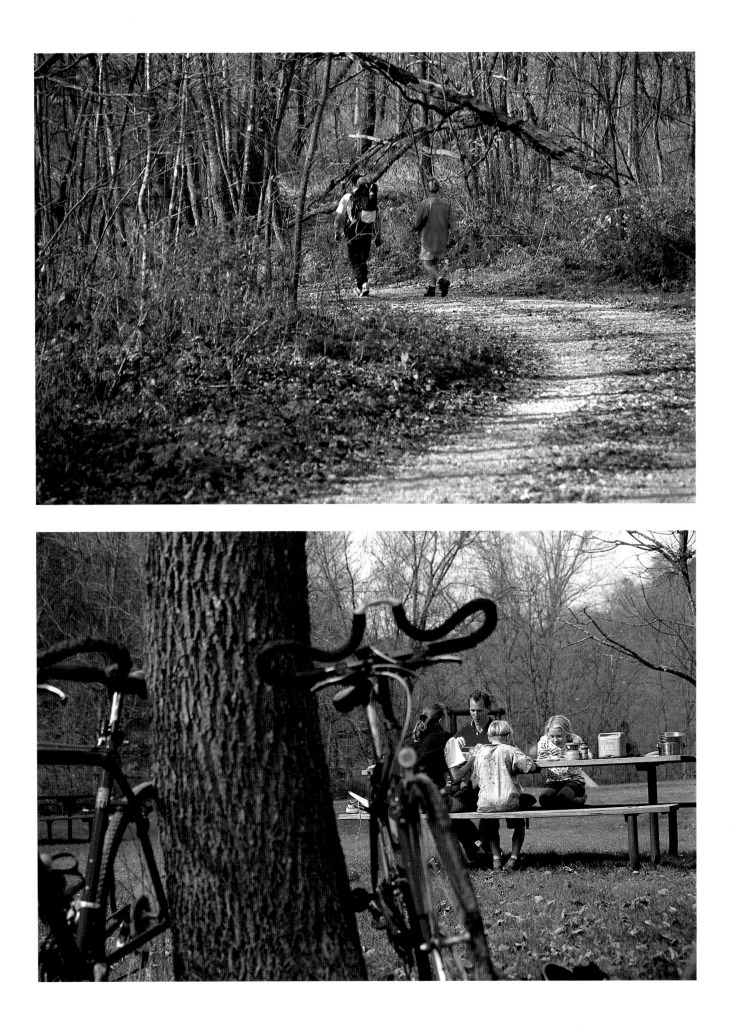

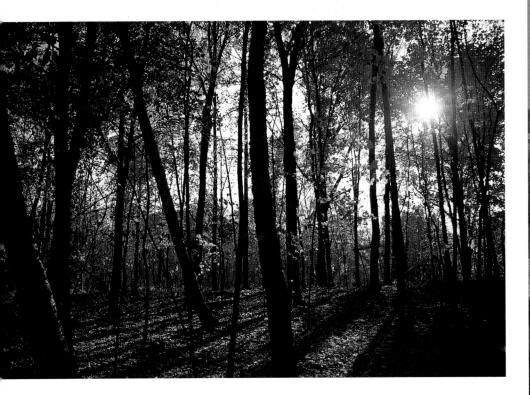

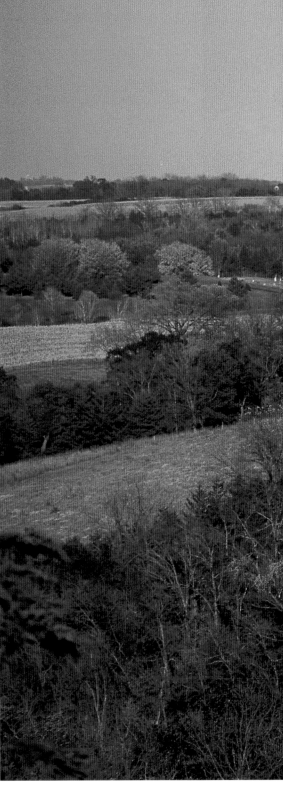

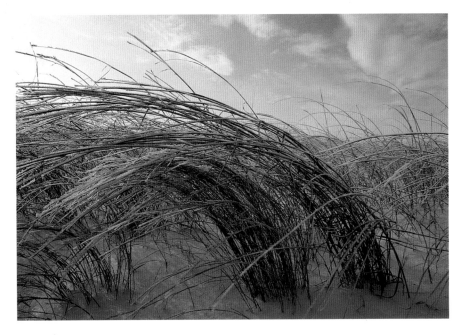

Top: *The sun peeks through the turning fall trees at John A. Latsch State Park.*

Above: *Ice crystals lock around each blade of grass, and the weight of the winter dew creates a sparkling windswept landscape at Afton State Park.*

126

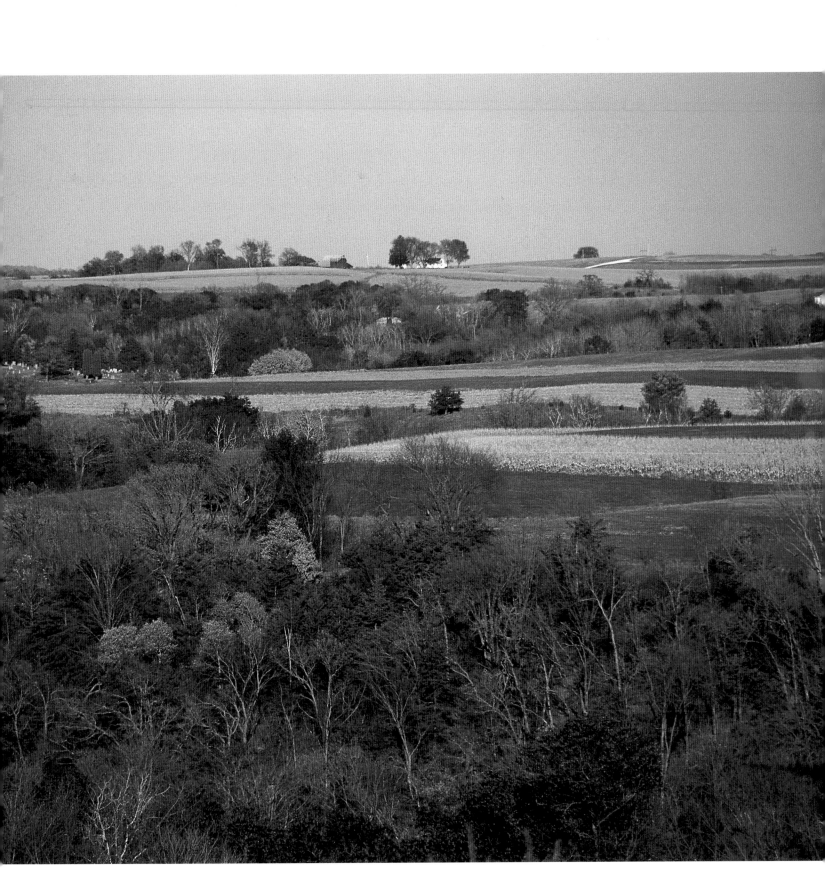

Rolling farmland creates a visual patchwork in Houston County, tucked into the far southeastern point of the state.

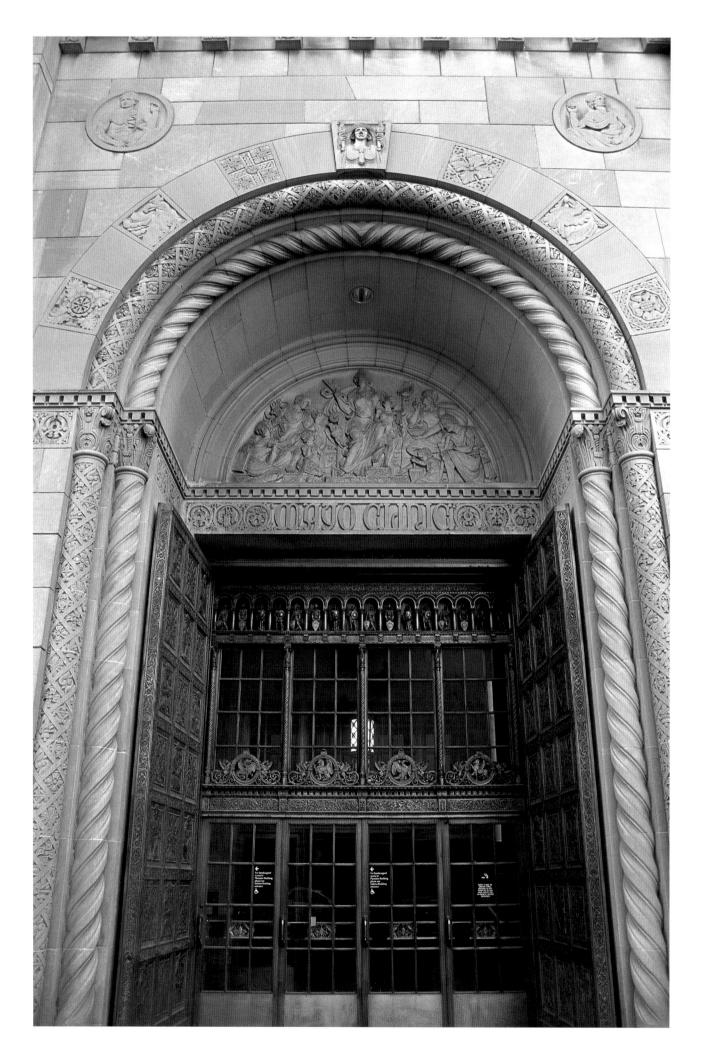

Facing page: *The world-renowned Mayo Clinic is Rochester's largest employer and dominates much of downtown.*

Above: *Mayowood, the historic Mayo family estate, welcomes visitors for organized tours, events, or strolls through its expansive gardens.*

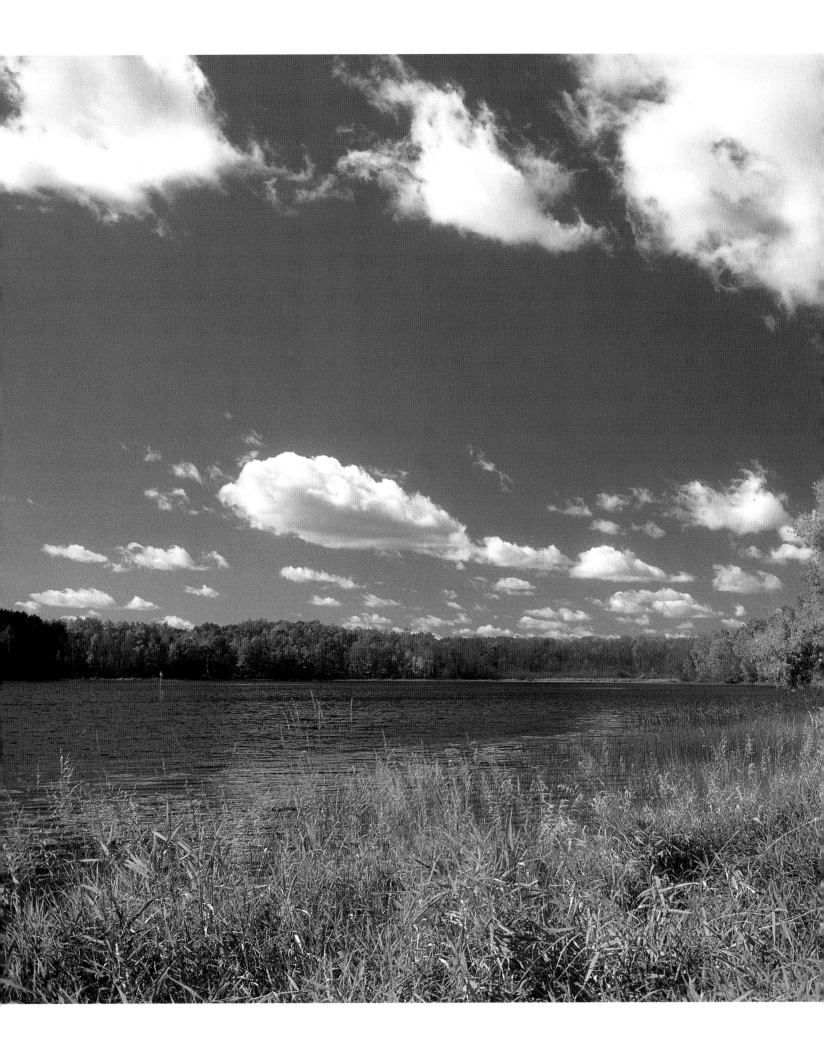

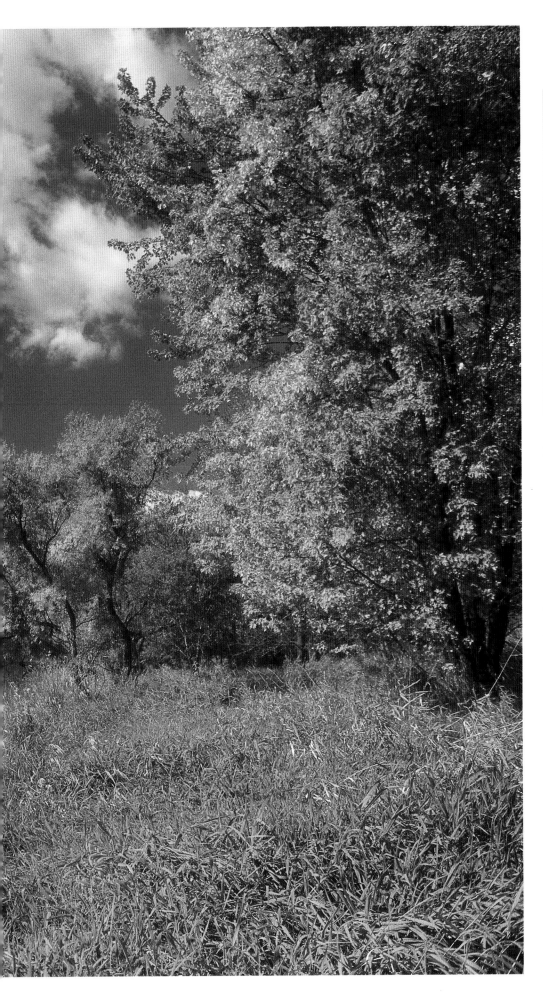

Left: *Moose Lake State Park was
established in 1971, and over the years,
it's developed into a well-rounded mix
of woods and fields, picnic areas and
campsites, swimming and fishing
waters.*

Above: *Spring raindrops cling to new
pine needles after an early morning
shower.*

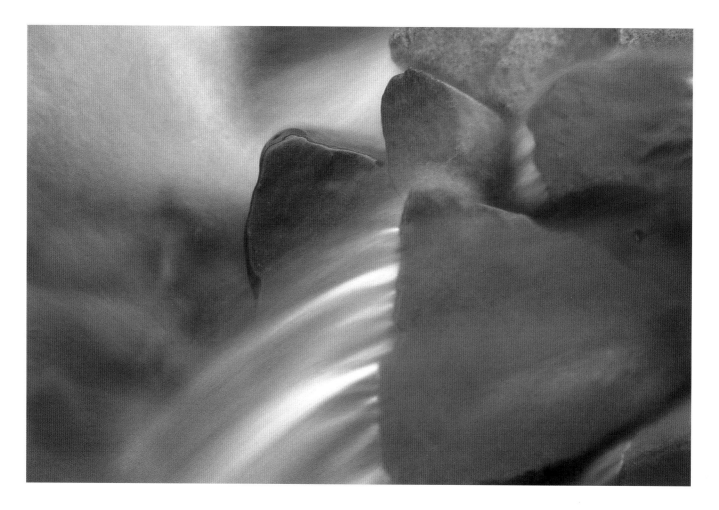

Above: *The Kadunce River weaves through rocks along Lake Superior's North Shore. Hikers can follow the river gorge on a two-mile round-trip trail from the Kadunce River State Wayside Rest a few miles northeast of Grand Marais.*

Facing page: *The stillness of Moosehead Lake in east-central Minnesota creates two sunsets, each complete with clouds tinged in pink.*

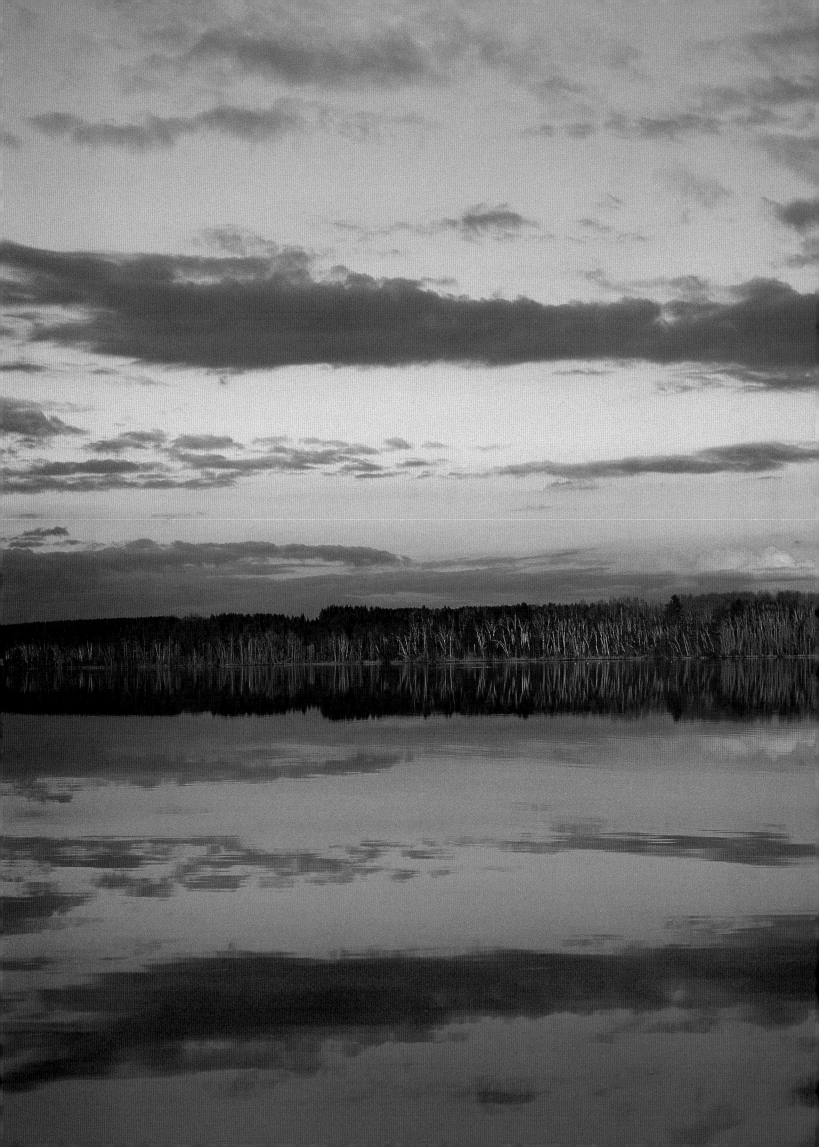

Tettegouche State Park is a North Shore hikers' paradise with rugged cliffs, cascading rivers, and three waterfalls on the park's Baptism River.

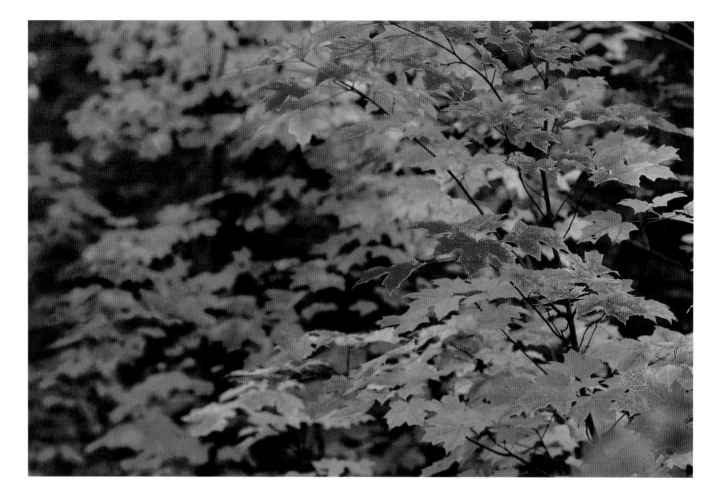

Above: *Because Minnesota's climate changes significantly from the north part of the state to the south, it's possible to follow the spreading fall palette in the same direction. On average, the northeast's aspen and birch reach peak at about mid to late September; the oaks and elms in the southeastern tip of the state are at their most colorful in early to mid October.*

Right: *About 40 percent of Minnesota's upper half consists of coniferous forest, with cone-bearing trees that keep their needles in winter.*

Color is everywhere you turn on this lush, tranquil trail in Jay Cooke State Park.

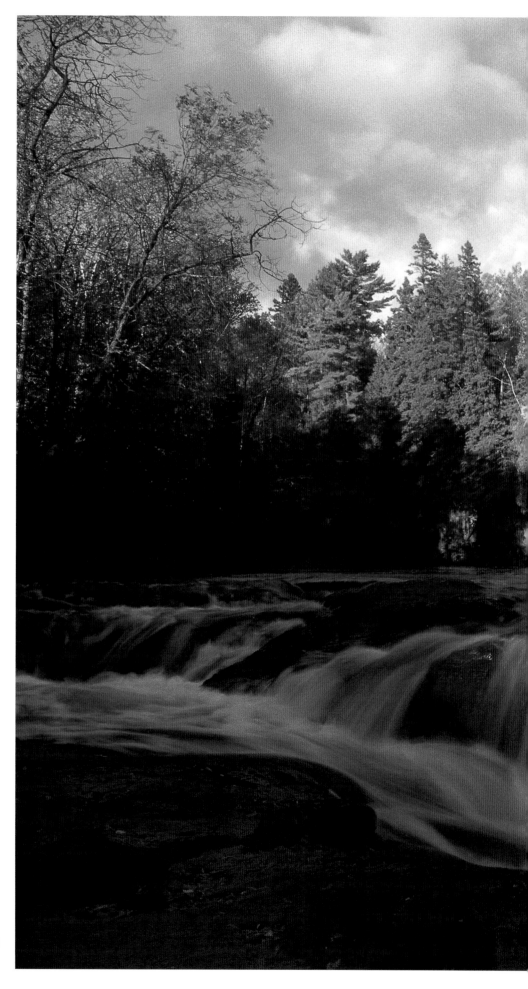

This is one in a series of five waterfalls along the Gooseberry River at Gooseberry State Park, a popular stop for Highway 61 travelers looking for a quick and scenic way to stretch their legs.

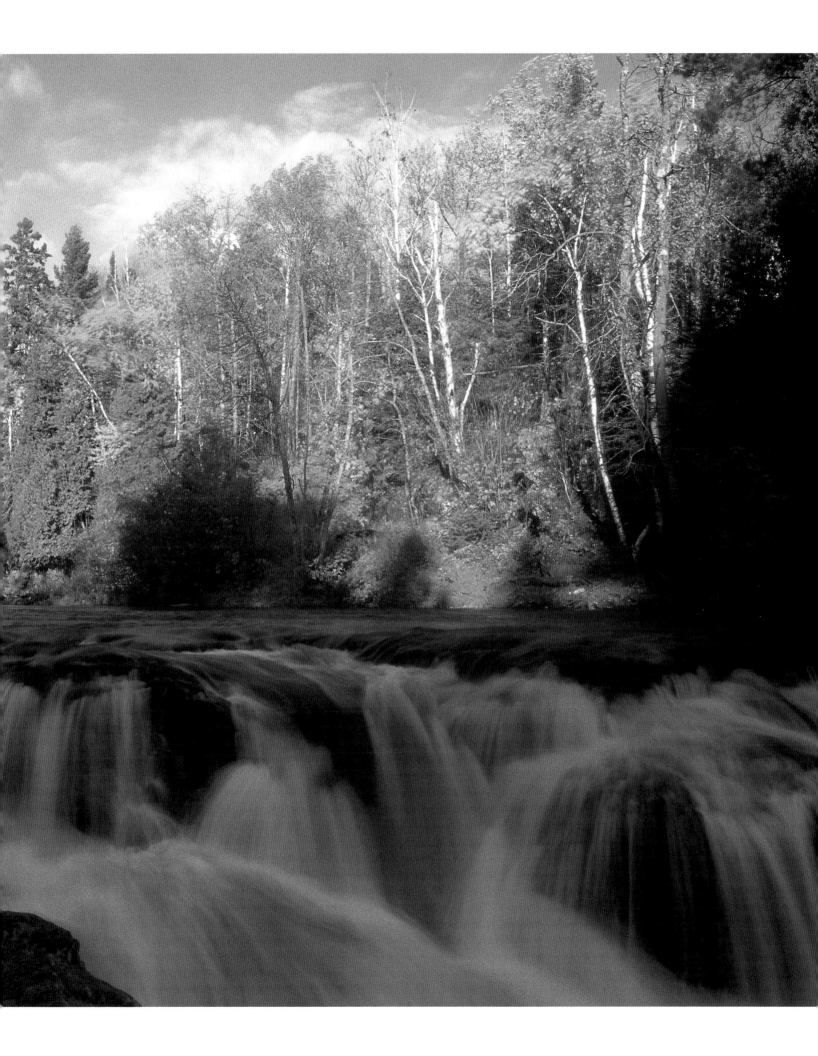

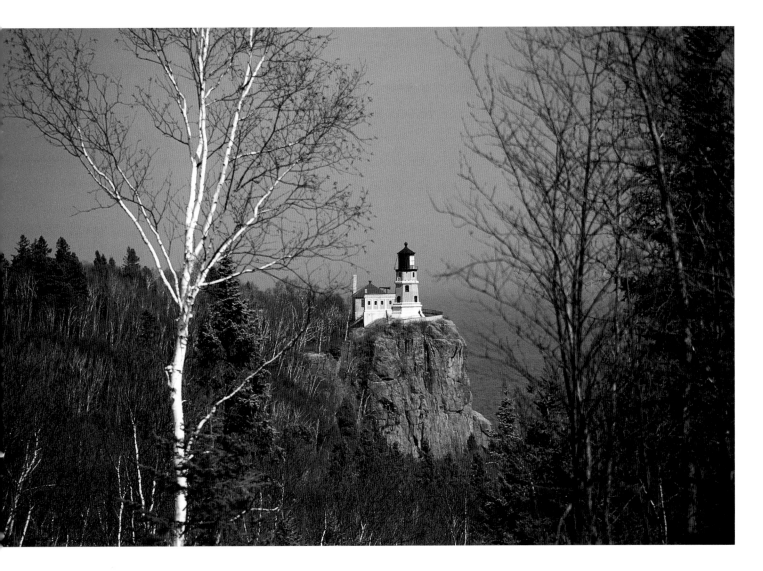

Above: *Most visitors come to Split Rock State Park to learn about the Split Rock Lighthouse, which has been restored to its 1920s appearance and is run by the Minnesota Historical Society.*

Facing page: *On nights when the aurora borealis are especially active, you can see them swirl across Minnesota skies—even despite the bright lights of the Twin Cities. Your best and most awesome bet, however, is to be far north, next to or on a lake, such as this one in Itasca County.*

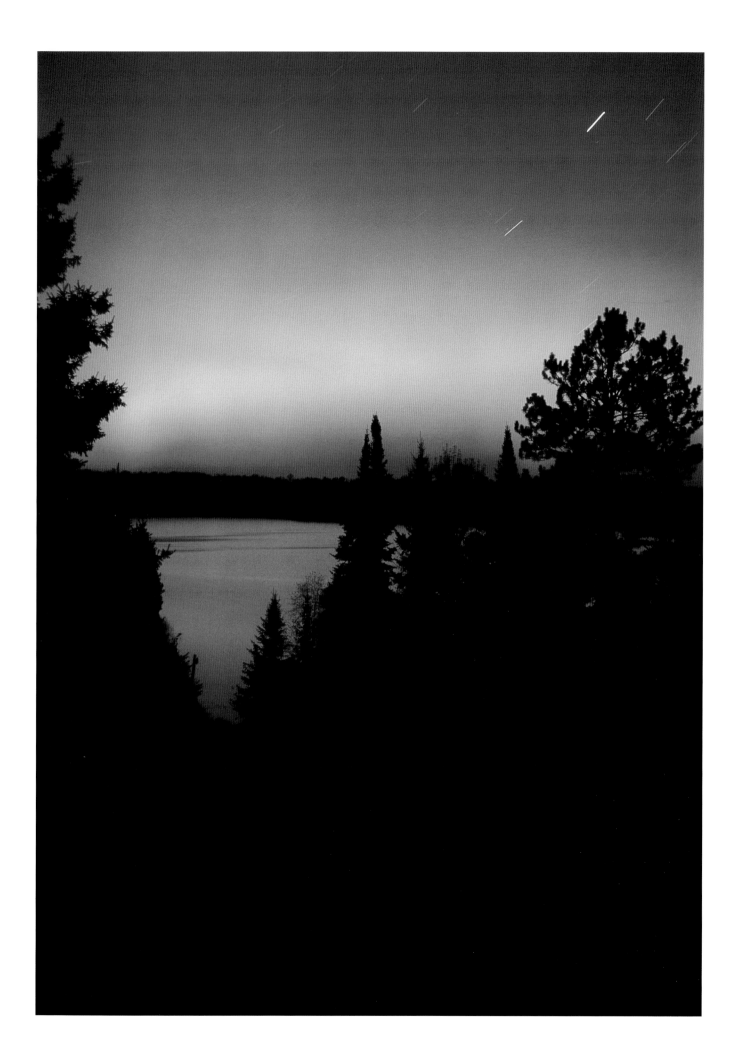